MAKING MOSAICS

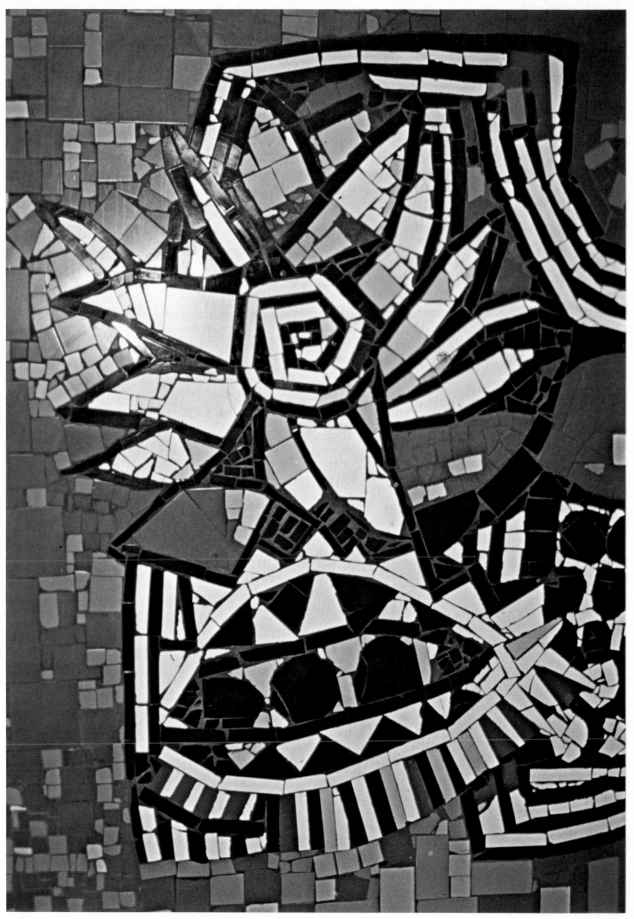

Tile mosaic by Antony Holloway, commissioned by the London County Council.

MAKING MOSAICS

Beatrice Lewis and
Leslie McGuire

DRAKE PUBISHERS INC.
NEW YORK

Thanks to the many artists who contributed their works; to the staff of Ken-Kaye Krafts of Newtonville, Massachusetts, for their advice and help; to L.S. Starrett for the generous loan of their fine carbaloid tipped nippers; to the American Crafts Council; to Harold B. Lewis for his excellent photographs.

Published in 1973 by
Drake Publishers Inc.
381 Park Avenue South
New York, N.Y. 10016

Library of Congress Catalog Card Number 72-10519
ISBN 0-87749-420-7

Printed in Italy

Prepared and produced for the publisher by BMG Productions, Incorporated

To my patient, helpful young
family, Shara, Adam and Ian, to
my husband Harold, whose
unfailing good humor and
know-how make all things
possible and to all thoese who love
to experiment.

Contents

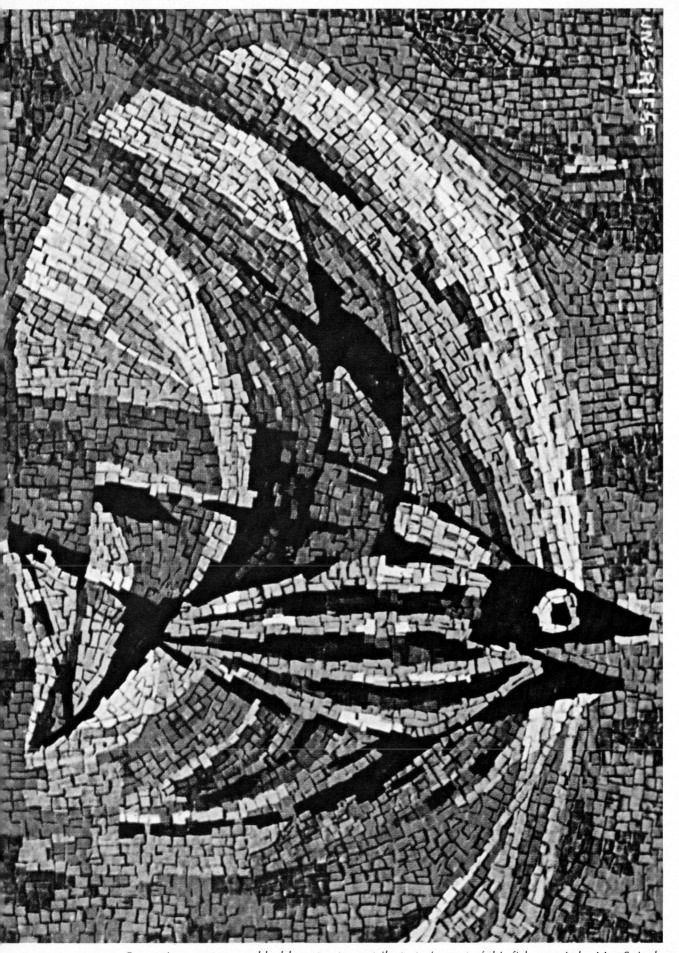

Repeating patterns and bold contrasts contribute to impact of this fish mosaic by Max Spivak.

Introduction

As a child, you were an artist. We all were. Each of us had, at some stage in our lives, that direct perception of nature—the innocent eye—that is the secret of creative artistry. It isn't just a matter of mastering techniques, although in most fields of the arts this, too, is important. The quality that sets an artist apart is that he has retained the ability to look at something and know intuitively that it is right, without knowing why or how. This simple naturalness is lost in most of us as we face the complexities of life.

In discovering the art of mosaics, you can recapture this "seeing eye." Your eyes will be reopened as you get the feel of creativity, putting together hundreds—even thousands —of tiny pieces of marble or glass or ceramic in an array of colors, watching patterns and pictures emerge as your fingers maneuver them. In this book, step by step, you will learn how to do it.

Although the word "mosaic" usually brings to mind ancient Greek and Roman floors or early Christian churches, mosaic making today is still as varied, creative, and beautiful as it was in the monuments of the past. In this book, we will explore the various methods of making mosaics and the vast number of materials that can be used to produce pleasing and useful pieces. The traditional materials of mosaic making are tiles of opaque glass, marble, and semiprecious stones. But there is no need to confine yourself to these. Objects found on the beach, at the hardware store or hobby shop, in the kitchen, or on the scrap heap can all be used to make mosaics.

One joy of mosaic making is that it is an area where artist and craftsman, hobbyist and beginner meet. You don't have to be a creative genius. Most of us have, in fact, untapped abilities in the area of design, and mosaic making can be a new way of expressing these talents. Not only is mosaic

"Queen of Malar" by Einar Forseth combines realistic details with a surrealistic approach to subject matter.

making fun; it is also relatively easy. With a small amount of technical knowledge, a beginner can produce truly impressive results.

YOU CAN MAKE A MOSAIC

Mosaic work highlights or adds texture to a surface. The side of a building or the top of a table are both suitable surfaces for a mosaic. Your mosaic can be something small—an ash tray or a trivet—or something very ambitious, such as your patio floor. A mosaic picture or sculpture is a good beginning project. As you learn, you can also produce an attractive piece of work. There will be many specific ideas illustrated in the course of this book, and these will undoubt-

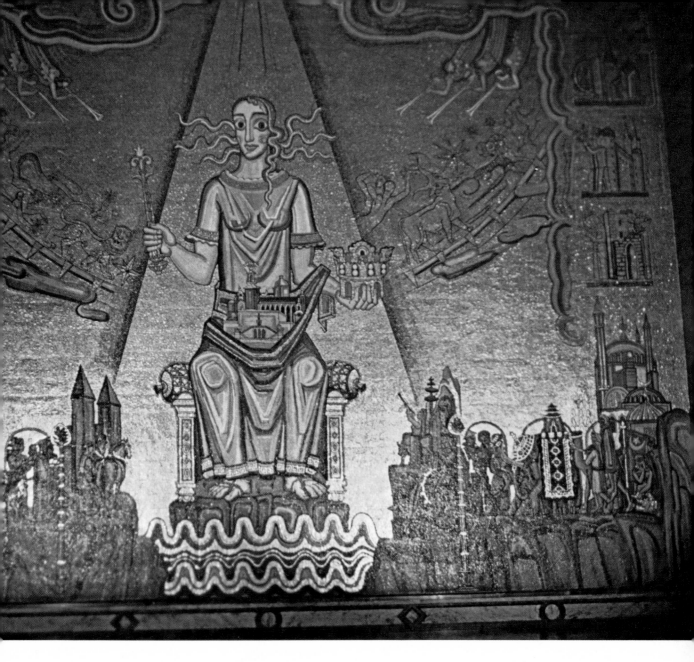

edly spark other ideas of your own—just follow your own
tastes and needs. This book will be a comprehensive and
highly useful guide to making modern mosaics. We will dis-
cuss old and new materials, adhesives, tools, and designs, and
describe numerous mosaic projects with easy-to-follow, one-
two-three instructions.

Mosaic making can be enjoyed by everyone, no matter how
old and young. Even five-year-olds enjoy handling and gluing
objects to form pictures, and school projects of paper mosaics
can be very handsome. Anyone who tries this fascinating
hobby will be rewarded by hours of enjoyment—and, even
more important, have the pleasure of making something
beautiful.

Many household objects can be decorated with mosaic design. Furniture can serve as a base for mosaic. The areas which are usually covered with tiles, such as bath or kitchen or the frame around a fireplace, can be covered with original mosaics instead. Three-dimensional objects and surfaces, such as lamp bases, decanters, canisters, or storage jars, can also be decorated with mosaics.

There are so many objects and materials that can be used as the components of mosaics that the scope of the art has become tremendously enlarged. Anything that is solid and can be glued to something else has potential as a mosaic material.

The aim of this book is to give you a more concrete idea of materials you can use and how you can use them most effectively. We will explore the visual effects that can be obtained by combining color, shape, texture, and form. And we will introduce you to many fresh and exciting ways in which mosaics can be used.

1
A Brief History of Mosaics

Mosaic making is one of the oldest art forms known. For thousands of years, people throughout the world have decorated objects and surfaces with mosaics. They have covered walls, floors, columns, shields, drums, sculpture, and jewelry with mosaic designs. These were made from many materials, from semiprecious stones and cut glass to pebbles, mother-of-pearl, wood, seeds, and even feathers.

THE FIRST MOSAICS

The earliest known mosaics are pebble floors, dating from around 7000 B.C., recently uncovered in the western peninsula of Asia Minor. These were certainly not the first mosaics, however. Cavemen, seeking to make their cave floors firmer underfoot, must have enjoyed placing shells and stones in patterns and watching the way the light played on their colors and surfaces. Pebbles and stones were used in early mosaics because they were plentiful and made a pleasing design. Then, too, they were durable and easy to clean, and in hot climates they were cool to the touch. (Mosaics are still used today for the same reasons.) Ceramic tiles were used later for the same purposes, and because they supplied bright color as well.

The first use of mosaics in an architectural setting occurred in Sumeria, around 2600 B.C., probably to relieve the tedium of Sumeria's massive expanses of temple walls. Cone-shaped colored pieces, like pegs, were embedded in mud walls and columns, decorating them and adding strength at the same time.

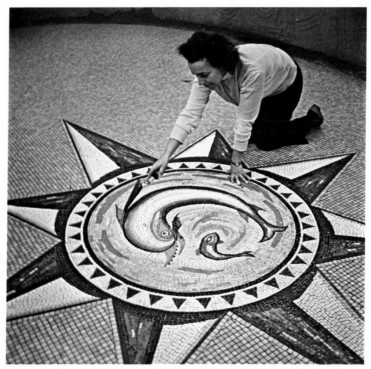

Geometric sunburst, designed and executed for swimming pool floor by contemporary artist Anna Wyner.

The Egyptians in 1400 B.C. decorated the tops of columns in the city of Tel-el-Amarna with inlaid colored glass and filled the spaces with gold, but the inlay work of the Egyptians cannot properly be called mosaic, for it was not assembled from fragments, but put together in individual, complete units.

GREEK PEBBLE MOSAICS

Mosaic pavements evolved in Western Asia; in fact, when the conquering Greeks arrived with Alexander, they may have walked on mosaic pavement in decorative patterns in two or three colors. But by then the Greeks were already familiar with mosaic art.

In Greece, the earliest mosaics we know were floors made of pebbles, naturally shaped and smoothed by the elements, set in mortar. The pebbles were generally black and white, in geometric or floral patterns. The earliest remnants we find were in the homes of the wealthy. It was a luxury art, enjoyed only by those who could afford materials and artisans. Here, mosaic was already a developed art; these early examples are beautiful in design and execution. The typical characteristics of true mosaic were already present: the pattern, in which each

element is built up from small pieces set into plaster; the interstices—the narrow spaces between the parts—which serve as an essential part of the form; and the slant of each piece in relation to its surface, which affects the quality and reflection of light.

Toward the end of the fifth century B.C. Greek artists grew more interested in color and in realistic representation; one artist was said to have achieved such a three-dimensional effect that birds swooped down to peck at his mosaic grapes.

In the late pebble mosaics, natural pebbles were not the only material used. To capture facial features and other parts of the design that demanded smaller pieces, the artists began to cut stone to their needs. The name for these shaped stones —*tesserae*—was later applied to other shaped mosaic elements.

ROMAN MOSAICS

In Rome, mosaic art took a new direction. It ceased to be a luxury art and became common—Rome's broad streets were paved with mosaics for even the commonest citizen to walk upon. Also, the roads of the Roman legion opened the way for sophisticated paving to spread all over the empire, from North Africa to Gaul, and even to the remote, provincial Britain.

Many Roman mosaics were highly pictorial. One charming Roman floor depicts the aftermath of a banquet, with all the leftovers scattered haphazardly about: old chicken bones, half-eaten pieces of fruit, and even a tiny mouse creeping out to sample the tidbits. Another Roman masterpiece, discovered in the House of the Faun at Pompeii, a rich site for mosaic art, is the Alexander mosaic—a dramatic confrontation between Alexander the Great and the Persian emperor Darius, done in various shades of only four principal colors: white, black, red, and yellow.

But the true Golden Age of mosaics arrived in Rome with the early Christians. Because of widespread persecution, they met secretly in dark catacombs, underground chambers, and tunnels with recessed alcoves for graves. The walls of these caverns were decorated with mosaics made of smalti—irregular bits of colored glass made by fusing sand and mineral

oxides. They told the story of the life of Christ to poorer Roman converts who could not read. Here, some two hundred years after Christ's birth, first appeared the symbols which were to become so prominent in Christianity: the dove, the phoenix, the palm, the olive branch, and the fish. Church walls in Rome and Ravenna are among the world's art treasures today.

BYZANTINE MOSAICS

When the Emperor Constantine became a convert to Christianity, his sponsorship made mosaic art flourish as never before. In the city of Byzantium—later renamed Constantinople, or City of Constantine—magnificent churches were built, with decorations so lavish that mosaic as a major art form is thought of as primarily a Byzantine accomplishment.

The smalti of the catacombs now brought mosaic art to its highest state of development. The range of colors, using this technique, is virtually unlimited. Moreover, for sumptuous effects, a thin layer of gold leaf could be fused between two layers of glass, the outer one being very thin. So the working materials of the Byzantine period range from glittering gold and blue to rich black, with lavish use of semiprecious stones and sometimes an effective use of reversed smalti, in which the color is visible through the clear glass.

THE DECLINE OF MOSAICS

The death knell of mosaic art on a grand scale came in the 16th century, when glassmakers discovered how to make glass in so many shades (some mosaic studios produced as many as 10,000) that mosaicists began to imitate painters. Mosaics became highly detailed and complicated. The dramatic starkness and stylized design that were the unique properties of mosaic art were lost. Mosaic artists forgot that their function —as dictated by their material—was to take the essence of a subject, simplify it, and depict it in fragmented pieces.

Where large mosaics had once decorated expanses of walls, the technology of glassmaking now made possible huge stained-glass windows, which served the purpose of decoration in churches. Another distraction was that painting itself, which in its most common form had been fresco—that is,

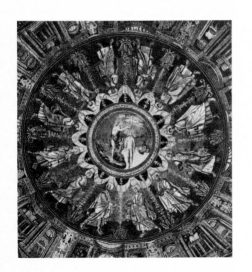

Fifth-century mosaic depicting the baptism of Jesus, church cupola, Ravenna, Italy.

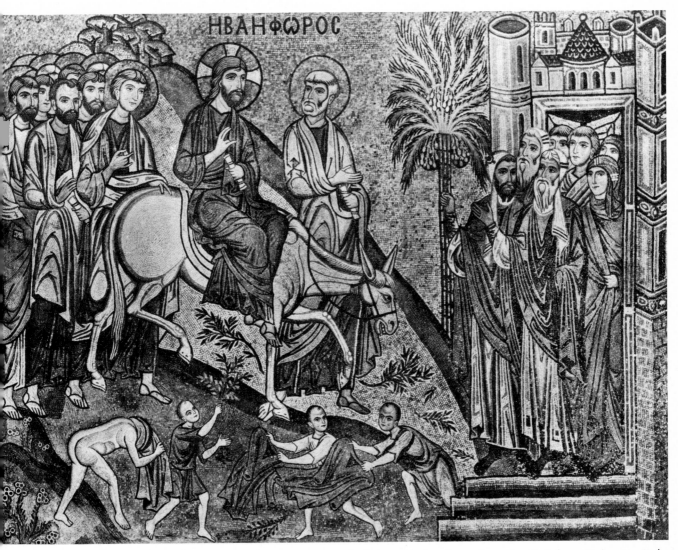

Twelfth-century mosaic of Christ entering Jerusalem, Reale Palace, Palermo, Italy.

ΗΒΑΗΦѠΡΟС

Contemporary mosaic by Unger-Schulze—an abstract rendering of a reclining figure.

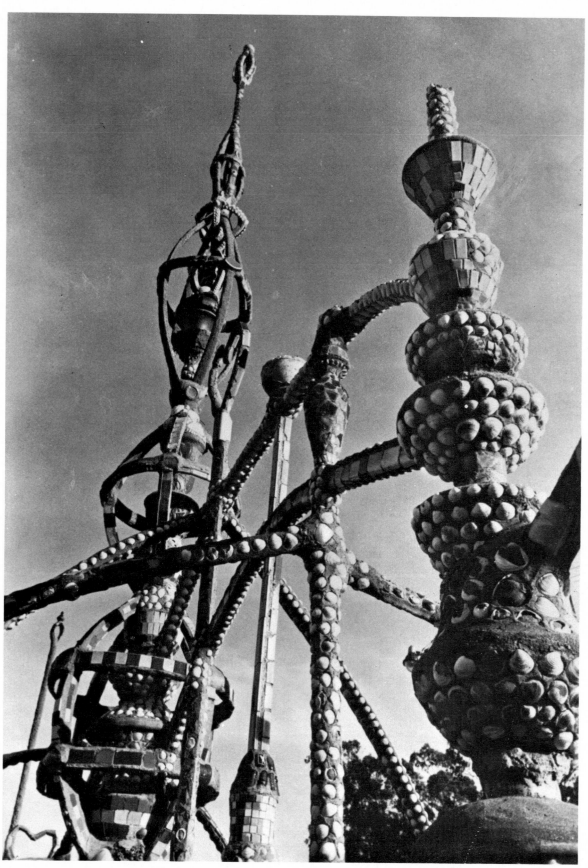

The Watts towers by Simon Rodia of Los Angeles, a powerful example of an imaginative approach to architectural mosaics.

painted on fresh plaster, and therefore a part of a wall or a building—had been freed by the invention of easel painting. Now artists could produce movable, flexible canvases—and there was a new middle class waiting to buy them. With the complexity and detail demanded by the Renaissance, the desire for simplification and stylization was lost. Not for several centuries would interest in the ancient art be revived.

In the Western Hemisphere, the Inca, Maya, and Aztec civilizations developed a combination mosaic-inlay technique to decorate jewelry and small objects. Using gold, turquoise, garnet, and obsidian, they created intricate designs of stylized figures and geometric patterns. Again, a later century was to see a rebirth of mosaic work in this area, this time on a monumental scale.

MODERN MOSAICS

In the modern era, in Spain at the end of the 19th century, Antoni Gaudí began using mosaics as an integral part of his architectural designs. In a completely new approach to mosaic making, he used broken bottles, plates, and figurines, as well as large pieces of ceramic and glass tile. Unlike the orderly, realistic monuments of the past, Gaudí's mosaics were powerful, tempestuous abstractions that complemented his sinuous, convoluted structures.

In the early 20th century, however, mosaics were not a popular medium for artists. In the United States only a handful of artists were interested in the possibilities of mosaics. Then, in 1950, the artistic world was electrified by the rediscovery of the magnificent Byzantine mosaics. When the Turks conquered Constantinople in the 15th century, the churches and cathedrals of the ancient city were made into mosques. For man to portray living creatures was, according to Moslem law, blasphemous, so the devout Turks had covered the mosaics with whitewash. They were only brought to light in the course of making repairs. Their beauty, when they were uncovered, sparked a whole new interest in mosaic making.

The early Christian work, with its dynamic designs, reminded modern artists of the power of this ancient art. As a result, a number of painters and ceramicists became intrigued with mosaics as a medium and set out to experiment. Through

mosaics, as in abstract painting, they could express a mood, distill an essential form, and disregard superfluous details.

Modern mosaicists quickly crossed the boundaries established by the traditional mosaic materials of ceramic, stone, and glass tesserae. They used paint with stone, mica with wood, smalti with metal—hundreds of combinations. New materials such as fiberglass and plastics also offered opportunities unknown to the ancients and gave modern artists an exciting chance to create distinctive and compelling art. The work of modern mosaicists is highly varied—in technique as well as in the use of many different materials.

Both Juan O'Gorman and Diego Rivera have made monumental architectural mosaics in Mexico, using colored natural stones. They combine stylized figures, pre-Hispanic symbols and patterns, and surrealistic designs to achieve exciting visual creations. Rivera's mosaic environment and mosaic sculpture of the rain god Tlaloc, in Mexico City, is perhaps the greatest modern mosaic work.

Jeanne Reynal of the United States not only works on murals and wall mosaics, but has also explored the use of mosaics to enhance free-standing forms. She uses traditional glass smalti and mother-of-pearl, but she sometimes scatters her materials loosely over the plaster bed, like an "action" painter splashing paint, thus introducing an element of chance into her work that the ancient mosaicists, carefully

Jeanne Reynal weds traditional mosaic materials with non-representational, organic forms.

placing tile by tile, would never have dared.

Elsa Schmid combines fresco—the ancient technique of painting directly on wet plaster—with mosaic. This allows for subtle areas of color which are highlighted and further defined by mosaic tiles.

Louisa Jenkins, another American, combines relief sculpture and mosaic tiles, offsetting the usual two-dimensional quality of mosaic murals and enhancing her three-dimensional sculpture at the same time.

Simon Rodia's neighbors regarded him as a mild eccentric in the 33 years he worked at building a series of towers in his backyard in the Watts district of Los Angeles. He covered the sides of his towers with bits of broken plates, bottles, and rubbish, along with machinery, tools, sea shells, and kitchen utensils—all worked into incredible patterns. Today we recognize the Watts towers as an approach to architectural mosaics that shows enormous inventiveness.

Although mosaic is an ideal form for embellishment of public buildings and monuments, not all modern artists create on such a scale. Juan O'Gorman's house is surfaced with colored stones, and Louisa Jenkins has designed mosaics for fireplaces, patio floors, and many other areas and objects used in the home. Professional artists and amateurs alike are discovering that the uses of mosaics are limitless, and that each project is challenging because each object or surface presents different problems in design, method, and materials.

Large chips of mother-of-pearl add textural interest to this free-standing sculpture by Jeanne Reynal.

2
How to Design a Mosaic

A mosaic is not a mosaic just because of the material used but because of the way in which the design is made. A mosaic is a fragmented design. Thousands of pieces of colored marble, ceramic, or glass, carefully placed one next to another, form the picture. Generally speaking, the pieces are equivalent to dots of color. But neither the smallness of the basic unit nor the regularity of its size keeps you from using great freedom in design and great variety in color.

THE ELEMENTS OF DESIGN

There are three main considerations in every work of art. Individual artists sometimes stress one more than another, but each plays an important role in design. The first is emotions —the artist's feeling toward himself and the world. The second stresses the formal structure of the work, and the third delves into the imagination. Feeling, order, and imagination should be present in every work of art because without order it would be chaotic; without imagination, it would be terribly dull; and without feeling, it would leave the observer unmoved. Think of these three considerations when working out your design.

For example, if you want to show a bird in flight, you must try to bring out the sense of total freedom embodied in his movement and yet maintain control over the placement of the mosaic pieces so that the whole arrangement of the work is expressive. The placement of the shape, the empty space around it, and the proportions all play a part in the design of your piece.

29

The wonderful thing about mosaic making is that it's practically impossible to have a disaster, even on your first attempt. Since *how* you do it is relatively easy, your major concern should be *what* you do. Before trying to decide what to do for a particular project, start looking around you at everyday objects. Begin to train your eyes to see the world in terms of forms, shapes, and patterns. Everything you see has order and design to it. Seashells, the leaves on a plant, half a grapefruit, or even a cell seen through a microscope—each has a pronounced and singular construction. Yet most of us scarcely see these things in our busy world.

PATTERNS AND REPETITION

Notice the contours formed by waves on the sand, and the patterns made by the late afternoon sun on these ridges; shadows cast by a fence on a sidewalk; rows of uneven rooftops; scaffolding silhouetted against a building under construction; the patterns of stacked girders or drainpipes at the site. All these things have a fascinating regularity if you look for it.

Photographs can also help you a great deal, as they transform three-dimensional objects and scenes into two-dimensional areas with definite boundaries. Photograph insects, tree bark, seed cases, or flowers and look at them under a magnifying glass to discover their basic design. You will see that each leaf and petal has its place in a pattern. Insects such as butterflies have highly symmetrical patterns and color formations on their wings and bodies. Each detail has a corresponding detail in the opposite position and they combine to make one unified design. When this type of symmetry is used in a decorative design it gives the impression of settled security because of the pleasing, comfortable expression of weight balancing weight. The eye can travel from the center and trace the direction of the composition without getting drawn out of the design completely.

A photograph can help you see the rhythm in an object or series of objects. When you organize shapes or patterns into a repetitive design, you are using one of the earliest design concepts. This concept is usually an essential factor in pavement or patio mosaics.

Designs can also be adapted from manufactured items such as pieces of lace, wallpaper, fabric, or china. And don't overlook items that you find in local junkyards, backyards, or

Symmetrical patterns drawn from nature.

garages. Gears, wheels, nuts and bolts, springs, the inner workings of clocks—all of these make unusual abstract designs.

A visit to the local museum can provide many ideas from its collection of folk and primitive art. Ancient jewelry and pottery exhibit a wealth of graphic symbols that you can use in mosaic designs. Designs and motifs of American Indians are highly adaptable. Before the widespread use of phonetic writing, symbols that represented entire words or thoughts were used for communicating. Impressive examples of graphic symbols are found in ancient Egyptian hieroglyphics.

If you're looking for design ideas closer to home, try cutting a vegetable or a piece of fruit in half and observing the patterns inside. Oranges, pears, apples, and even eggplants show

Ordinary objects and animals can become attractive design elements.

balanced, symmetrical designs. Their delicate colors can also serve as inspiration. Simple things often make the most beautiful patterns, and nature is one of the best designers around.

A design is a pleasing arrangement of shapes, colors, and textures. If you have already chosen the surface you wish to decorate, its shape may suggest what you should put on it. A good design depends not only on the choice of subject matter, but also on the way it utilizes space. It's important to fill the space—and to consider the space around your design as well. A large area with a skimpy design on it won't have the power mosaics are capable of producing.

The materials you choose to work with may dictate the colors and the textures in your design and they, too, play a part in guiding your choice of subject.

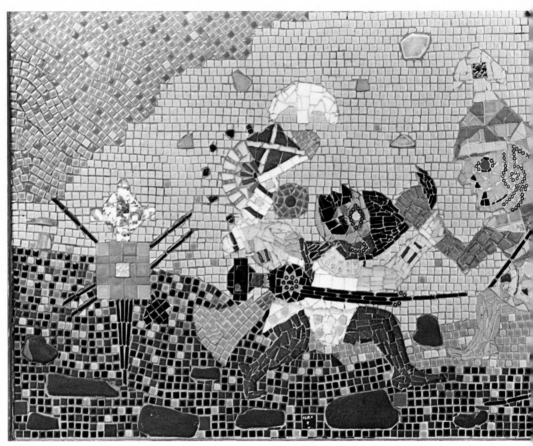

Stylized warrior figures against a background dominated by beiges and earth tones.

COLOR Both color and tone are important parts of your mosaic design. In your early attempts, it is best to work with just a few colors, to keep your design problems from becoming too complex. Colors are placed next to each other to contrast or flow together. Varying tones of the same color will blend, and the line between them will sometimes disappear. Contrasting colors will set each other off and define the different areas in your mosaic. As the pieces you are working with don't lend themselves to thin' lines, which will separate one shape from another, the use of color is extremely important in setting each area apart from the one directly next to it. When you

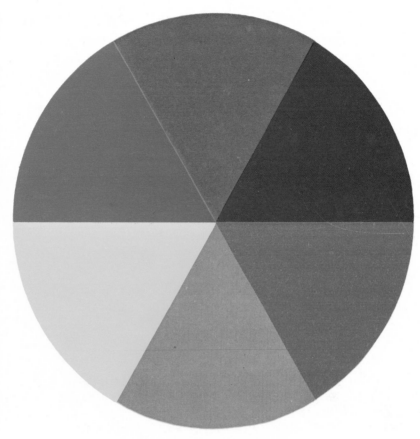

choose strong colors, try to avoid scattering them around the design because much of the definition will be lost. Work in solid-color areas at first—this will add power to your design.

It's a good idea to understand the relationship of one color to another. By examining the color wheel above, you will see which colors blend together most easily and which colors will set each other off to best advantage. The primary colors —yellow, blue, and red—are combined to make every other color in the spectrum. Those colors that appear directly opposite each other on the color wheel are contrasting colors and set each other off. Those colors which are directly next to

each other will tend to blend together when placed next to each other.

Again, your choice of material may affect your use of color. When working with natural materials the question of color is not hard to deal with. Wood, seeds, bark, or pebbles usually come in slightly varying shades of the same color. Here, texture will be of utmost importance. However, if you intend to combine natural materials with man-made tiles, it is best to use tiles in earth colors such as terra cotta, brown, red, soft greens, and yellows.

You can get color ideas from many different sources. If you are doing a realistic mosaic of an object, for example, you can take your colors directly from the original. If you are doing an abstract design on a lamp or coffee table for your home, you might pick one or two of the dominant colors in the room and combine them with a neutral white, beige, or black. Or you might choose a basic color from your room and then use all shades of that color in your mosaic. Watch for good posters or advertisements and note where they use a "shock" color as an accent, and in what amount.

Color, of course, doesn't have to be naturalistic. The most creative approach to using color is not to think of it in a completely literal sense. Your colors don't necessarily have to reflect reality, but can be chosen with design uppermost in mind. Apples are red, grapes are purple, and the sky is blue. But your design can be much more interesting if you experiment a bit with color and break away from the rigidity of realism.

In man-made tesserae, the quality of the color will vary a great deal along with the tone. If you use a mixture of different tesserae—ceramic, glass, or marble—you will achieve very lively effects in your piece. Of the classic mosaic materials, Italian smalti gives the finest selection of colors, shades, and half-tones. But this is expensive and hard to find. Glass tesserae have a quality all their own and are especially effective when backed with silver foil. The other possibilities don't reflect light to such a high degree, but many times this can be offset by spraying the finished piece with lacquer to bring out as much color as possible.

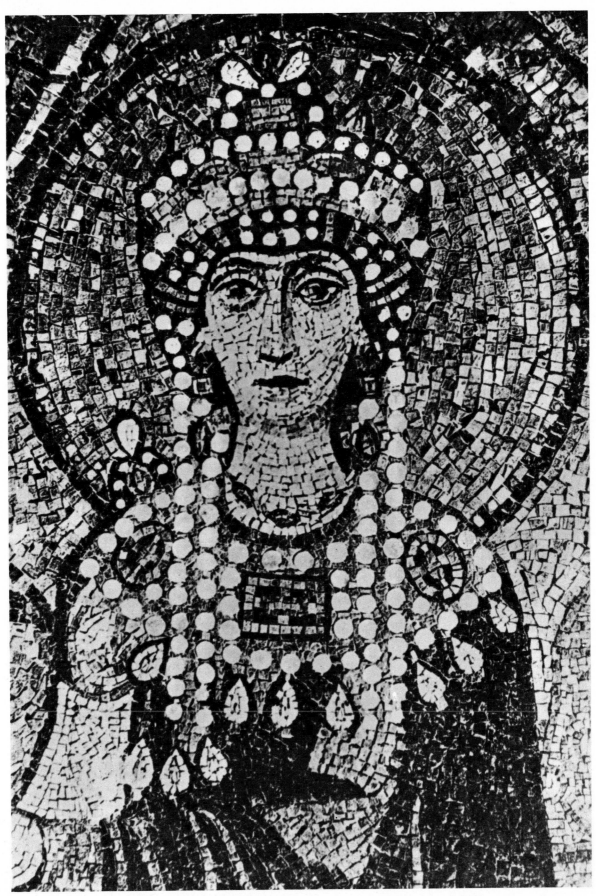

In addition to creating texture, flow pattern of tesserae functions as design element.
(Theodora mosaic, detail, Nuovo Ravenna.)

TEXTURE

Each mosaic material has a different texture and therefore reflects light in very different ways. Many modern mosaicists prefer to combine different materials to enhance the texture and reflection of their work. Often, using materials with the same basic color but different textures can create the same effect as using many different colors.

Many natural materials don't have any reflective qualities at all. When combined, however, their textures create different patterns which set them apart. If you are working with seeds and bark, collect as many different kinds as possible. Try to combine rough with smooth to achieve contrast.

When you set your tesserae in the adhesive, you can get a highly textured effect by tilting the pieces so that one side is set in deeper than the other side. This enhances the reflection, because in each area the light will hit at a different angle. When using smalti, this technique will give your piece a shimmering effect as you move around it.

As you are choosing your design, keep in mind the kind of texture you want it to have. An object generally considered very delicate, such as a butterfly, should not be highly textured—the essence of the butterfly would be lost. A mosaic depicting the curves of a shoreline can effectively use real pebbles instead of ceramic tiles.

Everything about your mosaic design should be carefully considered so that it will form a balanced and harmonious whole. Each element should enhance every other element; in this way, the unity of color, texture, and design will make a good mosaic.

Simplicity and significant emphasis should be the guiding principles of your design. Bear in mind where your piece is going to be placed because the piece shouldn't overpower its surroundings, and the surroundings shouldn't overpower the piece. This will, of necessity, impose certain physical limitations on your mosaic. But these limitations are part of the principles of a good ornament. The submission of an ornament to its surroundings makes it blend with and enhance the authority of the space it will occupy.

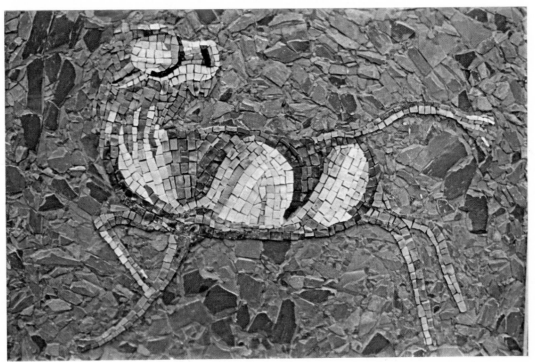

Rough-hewn, assorted tile pieces in background contrast with regular tesserae patterns used for the animal.

HOW TO BEGIN

When you get down to arranging your mosaic from the design you have decided on, it is most important to remember that instead of working in solid-color areas, you are working with tiny shapes that will be built into large areas. Each piece has to be carefully fitted to its adjacent pieces. A good way to practice is to try a paper mosaic first. This will give you the feel of manipulating small shapes for effect.

A pack of construction paper or an old wallpaper book will give you plenty of colors for this experimental mosaic. Tear or cut the paper into small shapes and place them on a strong colored background for a bit of drama. You can experiment with both the shapes you have cut, which are known as the positive shapes, and the remaining pieces, which are known as the negative shapes. Rearrange the pieces on your background until you have arrived at something you find exciting.

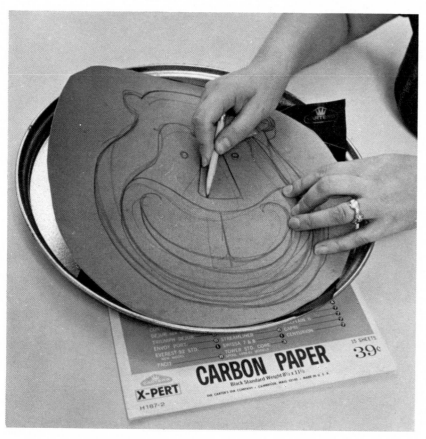

Making preliminary sketch.

Once you have the feel of it, you can better understand how to make your preliminary sketch. Working with such small pieces, it is always a good idea to have a fairly well-worked-out drawing you can refer to for color and shape while you are working on the actual mosaic.

Make this drawing with a thick magic marker or a soft crayon. A thin pencil line is not translated very easily into mosaic pieces. With a pencil, you will tend to produce a design that is too tight and intricate.

Another method of preparing a preliminary sketch is to use paper cut into shapes that you can manipulate into an interesting pattern. This will give you a great head start on translating your design into the mosaic pieces, since in the sketch you have essentially already done this.

If you are planning to try something realistic, draw a scene in your home or neighborhood. Remember that a mosaic must, because of the nature of the materials used, rely for effect on basic design rather than detail. An easy way to find

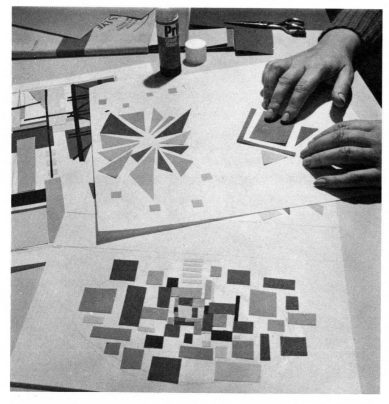

Working with paper shapes.

the basic lines in any scene or object is to half close your eyes and squint. In this way you will see the main contours of the scene and the details will drop out.

You can, for a first project, use a design outline that you've bought in a hobby shop, or you can trace a picture. This, of course, is a less creative, less adventurous approach. If you feel more secure doing this, try to make the picture "yours" by adding to the design or altering it to fit the surface you have chosen (See, for example, the table with a fish design on page 47.)

TRANSFERRING THE DESIGN

A drawing that is the size of the finished piece is called a cartoon. There are several ways you can transfer the cartoon to the object you are making. The simplest way is to draw it freehand directly onto the base with charcoal. You don't have to worry about making mistakes, as you can always redo this sketch until you are satisfied.

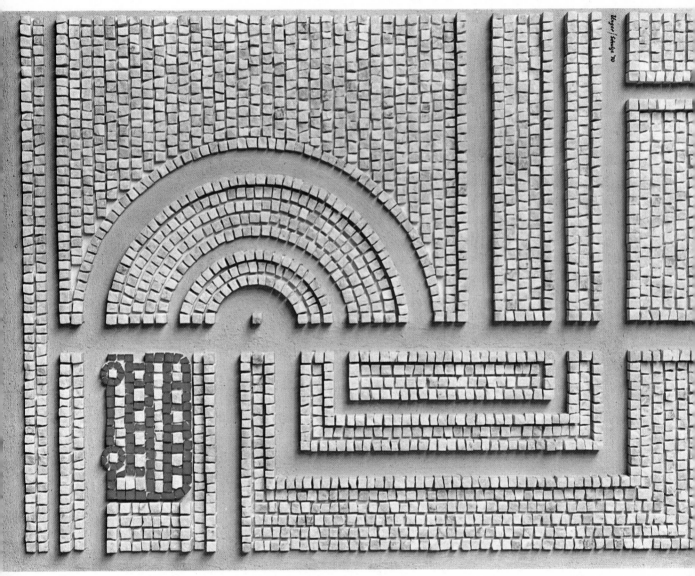

From a London Transport poster by Unger-Schulze. Background areas without tiles are an essential element in the composition of this mosaic.

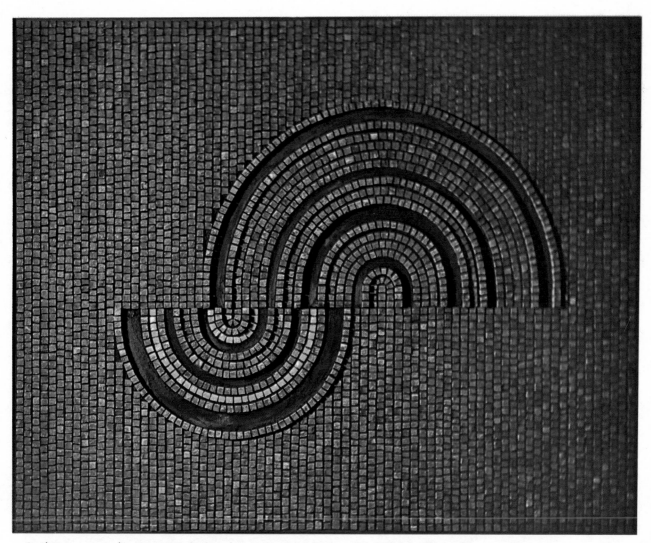

Striking mosaic by Unger-Schulze depends on bold, graphic design for its effect.

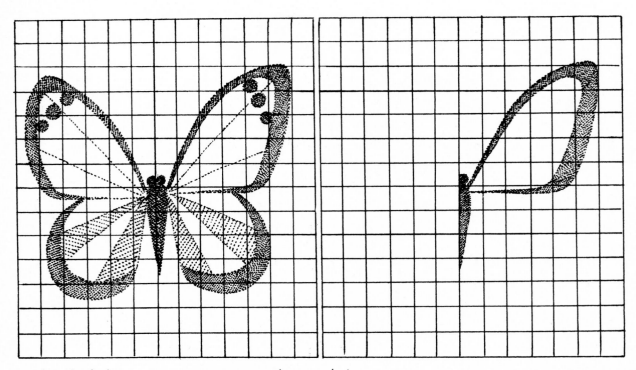

Grid method: the most accurate way to transfer your design.

If you are not confident about your sketching skill, make your drawing on a plain piece of paper, one that is the same shape and proportion as the finished work. Divide the paper into squares with light pencil lines. Then divide the mosaic surface into squares the same way. Copy the lines that occur in each of your design squares onto the appropriate square on the mosaic surface.

Another approach is to transfer the cartoon directly onto the base. You can do this by using carbon paper and tracing the design onto the surface. A simple substitute for carbon paper is to rub the *back* of the cartoon with a soft black pencil. Place the pencil-rubbed side down on the surface and draw over the design lines to transfer the design to the surface.

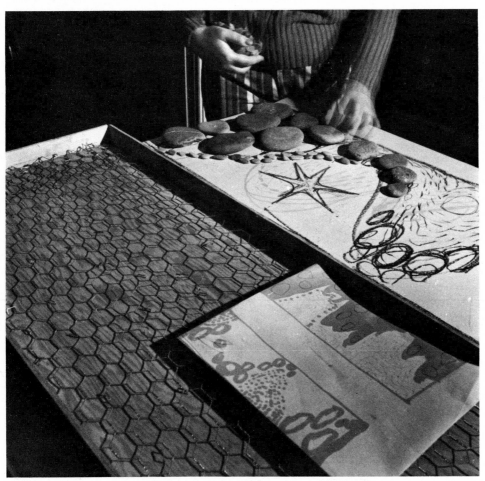

Always lay out mosaic pieces before working with the adhesive.

Once you draw the design, take a few of your mosaic pieces and check them for size against the design. If some of the pieces are too big for your small areas, change the tesserae —or change the design. This process is very important and will help refine and improve your design approach. It will show you whether your design will work well as a *mosaic*. Keep in mind that very tiny areas tend to be "lost" in a

The shape of an object can sometimes suggest an appropriate design. Here, circular table top and flowing curves of fish are complementary.

mosaic, which depends on strong, simple design for maximum effect.

Handling the tesserae and placing them in different patterns on the base may also give you new pictorial ideas.

At this point, color in your sketch so that you can refer to it as you are working. Once the adhesive is dry, it is difficult to change your mind and substitute one color for another, so it's best to have every detail of your mosaic worked out before you actually begin it. You can also make notes on your sketch about texture, direction of the tesserae, and tilting.

Study carefully the illustrations of ancient and modern

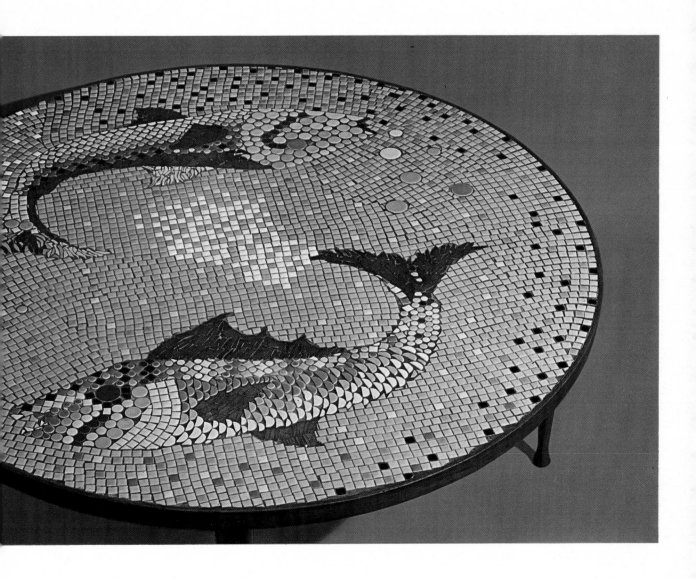

mosaics in this book. The more you observe, the better you'll understand how the artists obtained the effect of contour and movement. That is essential to a successful mosaic. Once you become aware of this design approach, you will begin to carry it through in your own mosaics.

Designing, like everything else, improves with practice. You just have to learn as you go along by trying different designs and different approaches. If you use an outline from a hobby shop on your first attempt, go one step further on your second—try one of your own designs.

3

Materials— Traditional and Offbeat

As we have noted, the small pieces of colored material embedded into adhesive to make a mosaic are called tesserae (plural; the singular term is "tessera"). *Tessèra* is Latin for "square piece." In ancient times small square pieces of wood, bone, or ivory were used as tokens, tallies, or tickets. Now, of course, the word refers to mosaic pieces.

The classic mosaic materials are smalti (glass) or marmi (marble). The finest quality tesserae available today are the Italian smalti, made in a factory that has been in the business for centuries. They come in a fabulous range of colors—as many as 10,000 shades—and their richness and beauty are unequaled. Unfortunately, not only are they difficult to obtain, they are terribly expensive, and certain colors are much more expensive than others.

The less expensive and more easily found mosaic materials are opaque glass tesserae, widely used in kitchens and bathrooms; ceramic tiles, which come in many different varieties, styles, and colors, some glazed and some not; stained-glass tiles, which transmit light and are usually bought from the manufacturer in sheets and then cut to size by the mosaicist; marble tesserae, which have very delicate and subdued colors; and linoleum, which is found in any hardware store and can be easily cut to size with scissors or tin snips.

All of these are of course still somewhat traditional materials. There are many, many things which can be used, such as seeds, pebbles and stones, wood, marbles, broken glass, and pottery. We have made a chart for you that outlines all the varieties possible and where to find them (page 60).

When choosing which mosaic material to use in your project, you should consider a few things beforehand. Some

Tiles offer wide color choice.

pieces have greater color intensity than others, and this of course will affect your design. Other materials are more suited for certain areas or uses, so keep in mind the placement of your work.

If the mosaic is to be used out of doors, be sure to use materials that won't be affected by the weather. Stones and pebbles, glass tiles, stained glass, and broken pottery can all be used out of doors. When embedded in a weatherproof adhesive such as cement, such materials make very interesting patios, walkways, or sundials.

When a mosaic is for indoor use, there are several things to think about. A wall hanging doesn't have to have an absolutely flat surface, and it makes very little difference if the materials are delicate or porous. However, if the mosaic is going to be in a kitchen or bathroom area where it is sure to get wet, use waterproof, nonporous tesserae and glue.

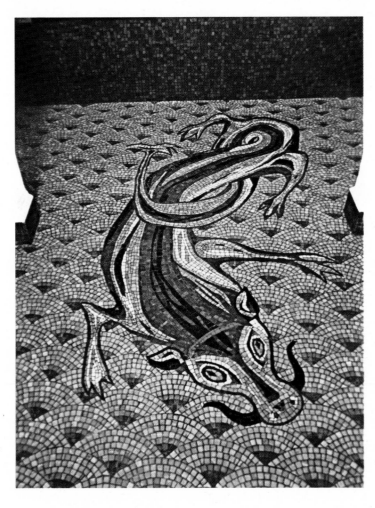

Bathroom floor with strong color contrasts.

Each year new materials are being developed, giving the artist a wider range of possibilities for his work. With the development of plexiglass and other plastics, substitutions can be made for both opaque and transparent glass tesserae. The imitation wood veneers now available from lumber yards and used as paneling will also make durable substitutes for wood mosaic pieces. It's a good idea to pay a visit to your local hardware store and lumber yard and just browse around, seeing what's available. Also, craft and hobby shops will carry all the latest materials, which, even if they were not originally intended as mosaic tiles, can easily be cut up and used to make interesting and decorative projects.

A list of standard and not so standard materials found at the end of this chapter will give you plenty of ideas about different kinds of tesserae. And don't forget that you can always combine different materials to achieve varied effects.

GLASS TILES Glass tiles are the material usually associated with mosaic making. They can be bought from Italy or from Mexico and are highly reflective. Shipped in small squares glued to paper, they are sold by the square foot. The pale colors cost least, and the strong, vivid colors, including gold and silver, cost most. To get the tiles ready for use, soak the sheet of paper until it can be peeled off the tiles, then cut them to the desired size with tile nippers.

Glass tiles can be used outdoors since they are nonabsorbent. They also make nice work-area tops or trivets.

STAINED GLASS This transparent material is best placed where it will transmit light, either as a window hanging or decorative lamp shade. The brilliantly colored glass pieces can be set on a sheet of clear glass or plastic. Used on an opaque backing, glass loses all its effect unless the base is lined or painted with some metallic substance.

Working with this material, you can combine it with opaque tesserae, giving the effect of mottled light and shade by letting the light glow through in some places and not in others.

Some hobby shops supply pieces already cut into squares, ovals, or heart shapes. However, the pieces also come in sheets that can be cut with a glass cutter. Always use transparent adhesives with stained glass. The cracks between each piece can be filled with liquid plastics or resins which are poured over the piece.

CERAMIC TILES The most familiar kinds of ceramic tiles are the types used for bathroom floors and tiled walls. There are many different kinds. Those that are glazed come in a variety of colors, whereas some have no finish at all. The glazed tiles are easily scratched, but are strong enough for work areas or coffee tables. The unglazed variety can be used on floors, but usually only indoors.

Although these tiles come cut in small squares, if necessary they can be easily cut with tile nippers.

It is also possible to make your own ceramic tiles if you have access to a kiln. You can achieve a great many fascinating textures and shapes this way. For more information on making your own ceramic tiles, see page 54.

LINOLEUM

The linoleum squares used to cover kitchen floors come in many colors and textures and are quite easy to handle. Although they aren't reflective, they are very serviceable and take a lot of wear and tear. Used on trays or children's work areas, they are attractive and durable. Light in weight and cheap, linoleum is a good material to consider when you intend to cover large areas.

Easily purchased in a hardware store or department store, linoleum can be cut with scissors or tin snips. You can also find a lot of good scrap linoleum around building sites.

SEEDS

Seeds and beans make an excellent mosaic medium, but remember they are rather delicate. They are found in such a number of sizes, colors, and textures that very interesting effects can be achieved.

They are best used as wall hangings, but, if set in a plastic resin adhesive, they can be used as decoration for more serviceable items such as the trivet on page 110.

Because they are so small, they can be difficult to handle. The best method is to use a pair of tweezers to place them in position. If you try to use your fingers, in all likelihood you will displace three seeds for every one you put down.

Always remember to bake them in the oven for about one hour. This kills any insect larvae that might be inside, and prevents them from sprouting when you least expect it. Always use a rigid base and spray the finished piece with lacquer to bring out the natural beauty of the seeds.

WOOD

There are many different types of wood that can be used as mosaic pieces. Scraps from lumberyards cut into suitable sizes, driftwood, veneer, bark, shingles, and bits of scrap such as spools make excellent tesserae. Although the color differences are subtle, the different textures, when combined, will achieve the same effect as a combination of different colors.

A walk along the beach or in the forest will provide a tremendous variety of different textures: wood that is salt bleached, smoothed by waves, decayed, eaten by insects, or charred by fire.

Not only can you achieve very interesting abstract designs, but you can also combine the pieces in such a way that they form a realistic picture.

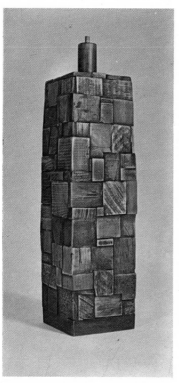

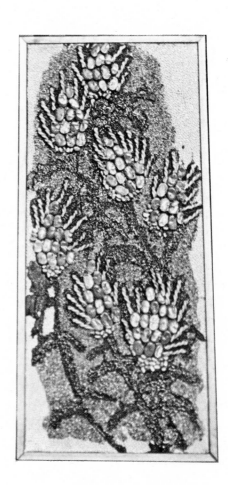

Natural materials add their distinctive textural and tonal interest (above, wood blocks; right, vegetables, spices, and seeds).

If you scrub the wood with a wire brush, you will dig out the soft parts and create interesting textures. Once your piece is completed, always apply some kind of finish in order to preserve it. Clear finishes will hold the color. If you wish to get as many different colors as possible, you can apply different stains to the pieces before you glue them down.

MAKING YOUR OWN TESSERAE

CERAMIC TILES

Do you have access to a kiln? If you do, and if you want special colors or effects, the simplest thing for you to do is to make your own tiles. Use porcelain or regular firing clay that can be bought at a hobby shop.

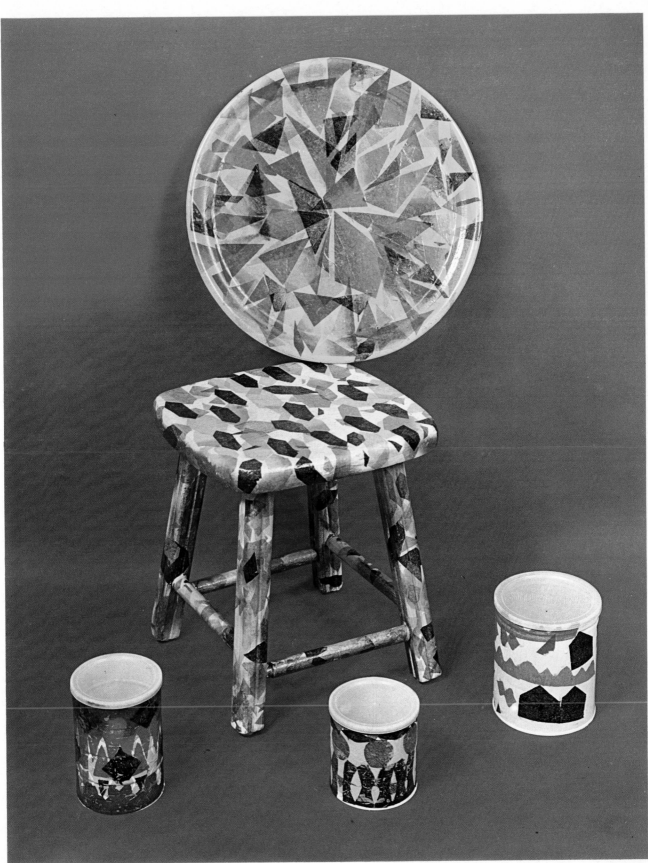

Easy-to-make tissue-paper mosaics add a cheery accent to work and play areas.

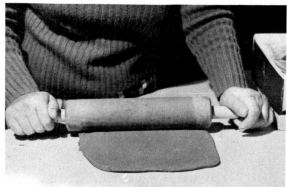

Roll clay out evenly.

Add texture.

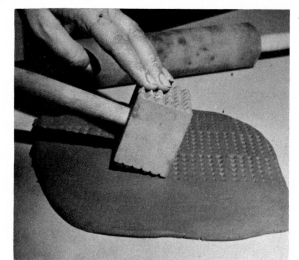

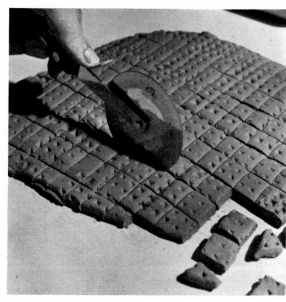

Cut out desired shapes.

Make sure you wedge the clay well before you start working with it. Wedging is done by forming the clay into a ball and then slamming it down on a flat surface—preferably plaster, which soaks up the moisture, but wood will do. This removes the air bubbles. Take a rolling pin and roll the clay out evenly to about ¼″ thickness.

Texture the clay any way you like. Then cut out the shapes you want with a pastry cutting tool. You may wish to paint on a glaze before you cut.

Let the pieces dry completely and follow the firing directions for the kiln.

If you don't have a kiln or rock tumbler, look for rounded bits of glass on the beach.

Colored glasses, bottles, and jars are cheap and plentiful. You can be your own ecology way station, collecting all the discarded bottles you find and then "recycling" them into your mosaics. They are very good for use outdoors since they are nonporous and unaffected by the weather or general wear and tear, but they are equally effective used inside.

To break the glass into workable pieces without cutting yourself, put the bottles into several paper bags or between wads of newspaper. Holding the top closed, hit gently with the flat side of a hammer or mallet. Watch out for tears in the bag.

When you are through, choose the pieces you want to work with. To keep from cutting yourself on the sharp edges, it's a good idea to smooth them down. This can be done in two ways. Put them into a rock tumbler, or, if you have access to a kiln, melt them down so they resemble drops of liquid. When they have reached the melting point, turn off the kiln and allow them to cool inside. If you remove them when they're hot, they will fracture.

BROKEN GLASS

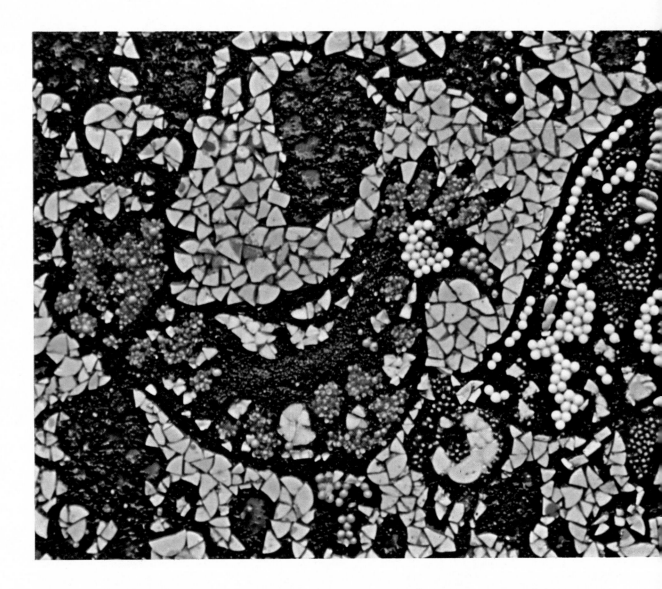

STONES AND PEBBLES

It's a lot of fun to start where the ancients did so many thousands of years ago—with pebbles and stones. They're easy to find along the beach, by streams, in gravel pits, or in florists' supply houses. For the most part they cost nothing. Wash them off to get rid of the salt or earth (you can see their true colors when they're wet), sort them according to size and color, and put them into transparent containers. Stones and pebbles are excellent for outdoor projects, and are very effective inside as well.

You can use them just as you find them, or you can polish them in a rock tumbler to bring out their natural colors and highlights. If the piece is only for indoor use and won't be exposed to water, you can paint the pebbles with a clear lacquer or spray with silicone spray once the piece is finished.

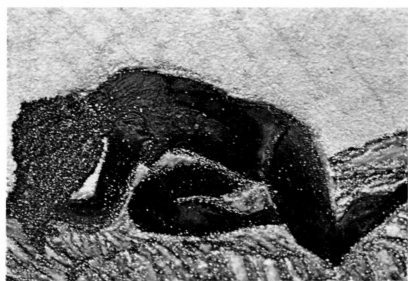

"Vegetarian" mosaics by Patricia Wirtenburg (left and above) achieve very different stylistic effects with such materials as instant coffee, Necco wafers, and Egyptian lentils.

BROKEN POTTERY AND CHINA

Broken pottery, glazed or unglazed, makes an inexpensive, colorful mosaic material that can be used indoors and out. It also combines very well with stones and pebbles. Beach glass and shards found in the ocean have a lovely patina.

Put the large pieces inside a few paper bags or folded newspaper to keep them from flying around and hit gently with the flat side of a hammer or mallet. You can use the pieces in the shapes they break into, or use tile nippers to cut them into the sizes and shapes you need.

Broken pottery with curved surfaces is best sunk into cement. This covers the sharp edges and, to a degree, eliminates the bumps if you want a flat surface.

MATERIAL	WHERE YOU CAN FIND OR PURCHASE IT
shells	beach, hobby shops, junk shops
pebbles	streams, shore, gravel roads, flower shops, horticultural nurseries
wood	scrap wood from framers, toy makers, furniture builders, lumber yards
driftwood	beach, lake, floral shops
veneers	lumber yards, specialty manufacturers
minerals and rocks	lapidary shops, mines
stones	gravel pits, garden supply shops, gravel roads, beaches, streams
stone chips	quarries, garden supply shops
marble	waste given away at quarries or by tilers or tombstone makers, flooring suppliers
foods and seeds	food stores, garden, woods
smalti (Byzantine tesserae)	made in Italy; classic mosaic material, very expensive; superior in its reflective qualities
Venetian glass	tilers, building suppliers, hobby shops; inferior to smalti
opaque glass	old, veined glass—a treasure if you can find it in a wrecker's yard
stained glass	waste from stained glass works, wrecker's yard, hobby shops
marbles	toy shop
mirrors	hobby shops, junk yards, mirror shops
plastics	plastics manufacturers, hobby shops
ceramic tiles	plastics manufacturers, hobby shops
ceramic shards	from some beaches, or broken from chipped china; can be tumbled in a rock tumbler
paper	tissue, gift wrapping, newspaper, colored magazine pictures, foil, candy wrappers, construction paper, scraps, art supply shops

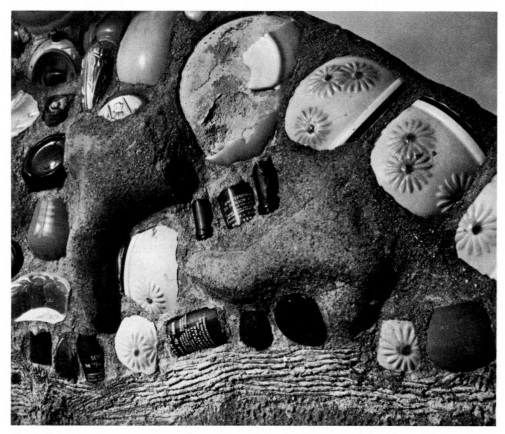

Detail of Watts towers: large fragments of found objects are used as mosaic pieces.

fabric	decorator samples, sewing discards, fabric stores
beads	hobby stores, junk shops, discarded costume jewelry
buttons	by the pound from some fabric shops and mail-order stores or from manufacturers
linoleum	hardware stores
formica and vinyl	building suppliers, bathroom and kitchen builders' scraps
plexiglass	hobby shops

broken glass	melted in kiln	**DO-IT-YOURSELF**
ceramics	textured, glazed, and fired in kiln	**TESSERAE**
stones	smoothed and polished in a rock tumbler	
glass	smoothed and polished in a rock tumbler	
broken pottery	sanded or used as is	

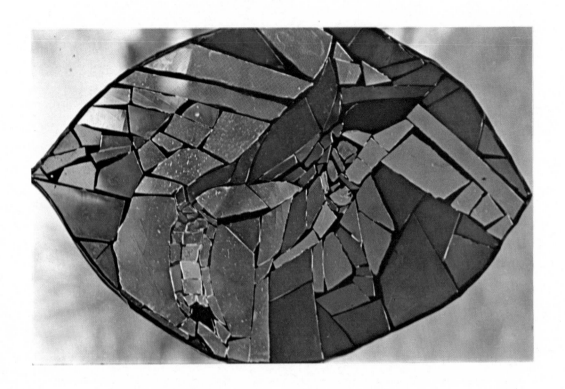

4
Tools, Equipment, and a Place to Work

Since making mosaics is often a rather messy affair, and the materials take up a lot of space, it is a good idea to set up a work area for yourself. Putting together a mosaic is rarely accomplished at one sitting, so find a space where you can leave everything until the next time you get a chance to work on it. Of course, a complete studio would provide ideal working conditions. However this isn't always possible—nor is it absolutely necessary, either.

Most important is a good-sized work table. This will allow you plenty of room to spread out your cartoon, your containers of tesserae in all the colors you're using, and your base . . . not to mention glues, grouts, and whatever tools are necessary. The table should be in a spot where the lighting is good. Natural sunlight is best, and if you can work outside you will eliminate many lighting problems. Natural sunlight shouldn't shine directly on your work, however, because it's very difficult to use the glass tesserae when the light is reflecting into your eyes. If you use artificial light, the fixtures should be as close to the ceiling as possible. If they give off a strong, diffused light, there will be no glare on your piece, and the light won't cast annoying shadows.

Always spread a drop cloth or newspapers under and around the table. When you cut the tesserae, the pieces have a tendency to fly around and make a mess on the floor. Again, working out-of-doors will take care of this problem easily.

A stool that can be raised or lowered should be part of your studio, so that you can adjust the height of the stool and avoid long hours of standing and stooping over the work table.

YOUR WORK AREA

Another very important part of your work area is the proximity of a sink and running water. When you mix your own mortars and when you prepare grout, you should be able to get water easily. This also simplifies washing up afterward.

You'll inevitably accumulate lots of jars, bottles, mixing bowls, odd bits of wire and wood, glues, adhesives, and general tools, so shelves and cabinets are a must. Nothing is more irritating than to be working with an adhesive that has a working life of 45 minutes and be unable to find all the things you are looking for.

And last but not least, you should have a waterproof garbage pail close to the sink.

Try to set aside a special corner for your work if your house is too small to use an entire room. Although it is quite simple to work on the kitchen or dining room table, this means that you won't be able to leave work in progress out for a day or two. When you do leave work out, always make sure it is out of reach of small children and animals. The tiny pieces are sharp, and could be a hazard to small curiosity seekers.

TOOLS

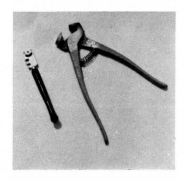

Tile nippers (top and bottom) and glass cutter (top).

Very few specially bought tools are needed for this hobby. In fact, a *tile nipper* may be the only tool you have to buy for most of your projects. The tile nipper will cut glass, glass tiles, and ceramic tiles by fracturing them. With a bit of practice it's easy to become quite proficient and accurate. The price of a pair of tile nippers ranges from $1.50 to $15.00, but for about $2.50 you will probably be able to find an adequate pair. Many professionals like to use a pair with carboloid tips to ensure accuracy when cutting. Whatever kind you buy, check to see that the pincers come together in a straight line.

The advanced mosaicist may want to use a **hardie** on which to split smalti, marmi (marble pieces), pebbles, or glass marbles. A hardie is a wedge-shaped piece of steel firmly secured to a base. The base can be made of a coffee can filled with plaster or cement, a tree stump, or a heavy piece of wood.

You might also wish to buy a **glass cutter** if you are planning to make a glass mosaic, and a **Bema cutter** for cutting formica.

Of course the most important piece of equipment which you should have and *always* use is a pair of **goggles** or an **eye**

shield. Always use them when cutting or chipping your tiles, because the small pieces have a tendency to fly around. For added protection, cup your free hand around the edges of the cutter as it bites into the tile.

Most of the necessary items used to complete a mosaic are found around the house, so they really aren't considered tools. They are hammers, scissors, a rubber spatula, bowls and cups, tweezers, a rolling pin, and a wide-bladed screwdriver.

Checklist

hammer—for breaking pieces of tile or glass

scissors—for making cartoons and paper mosaics

rubber or plastic spatula—for scraping the grout or adhesive from the face of your mosaic; never use a metal scraper because this will mar the surface

jars, shoe boxes, bowls and cups—to separate all your tesserae

tweezers—for placing a small tessera without moving any of the adjacent ones

rolling pin—to press all the mosaic pieces evenly into the mortar

screwdriver—for taking out any misplaced tesserae.

Bema cutter

ADHESIVES

The tesserae must be firmly glued to the base, so it is most important to use the right glue. Each material you use has different properties, and you must consider these before you begin. If you are using heavy tesserae, such as stones or rocks, you must use a strong adhesive. Light tesserae such as seeds need only white glue. You must also consider where you are planning to put your mosaic, and what it will be used for.

Generally speaking, anything you do will fall into one of the following categories. Since these all indicate a different amount of wear and tear, different types of adhesives must be used.

INDOOR PIECES

• Indoor pieces which are used as pictures or wall hangings. These are not intended to be functional.

• Indoor pieces that will be used, but aren't likely to have too much contact with water. These would include trivets, ashtrays, and trays.

• Indoor pieces or areas that are going to be constantly

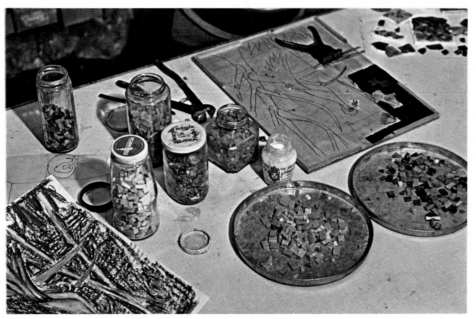

Necessary material on workbench.

splashed and wet. This would mean a mosaic surrounding the kitchen sink or the shower area. Anything like a countertop or work area should be included also, since a lot of washing up might take place there.

OUTDOOR PIECES

• Any outdoor piece that you make will have to be impervious to the weather. Therefore, not only should you use nonporous tesserae, you should also use a nonporous adhesive. The best outdoor adhesives are cement or concrete.

TRANSLUCENT PIECES

• Pieces that are intended to transmit light and show off their glowing colors must be set in a transparent glue. This way, there is nothing that gets in the way of the light passing through.

Because adhesives are being devised all the time, a trip to the hardware store to check out the various types is always helpful. Since you can use such a variety of materials for your tesserae, you will find that there is usually a commercial glue made for whatever material you use. There are, however, certain basic adhesives which aren't so specific.

CASEIN GLUES

Most indoor wall hangings and other pieces that won't be exposed to much water can be affixed with casein glues. Milky in color when applied, they dry transparent. These glues are not very water-resistant, but they are quite strong. These glues

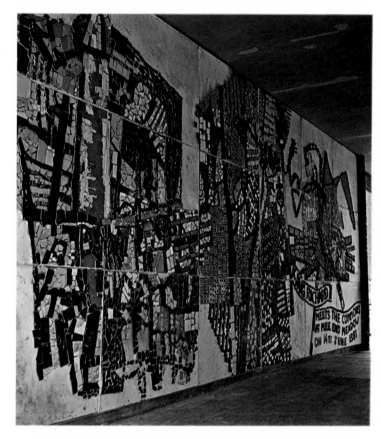

Outdoor mosaic uses broken and cut tiles.

can be used with small pebbles, seeds, ceramic tiles, glass tiles, or wood. Simple paper mosaics can also be affixed with casein glues.

Another important use of these water-soluble glues comes up in the indirect method of applying the tesserae (see page 91). In this method, since you are placing the tesserae upside down on a sheet of paper and then laying the completed design directly into the cement, a water-soluble glue is used in the primary setting. In this way, once the adhesive on the base has dried, the paper can be dampened and peeled off, leaving the tesserae set smoothly on the surface.

Using casein glue.

POLYVINYL ACETATE RESINS

Polyvinyl acetate resins are quite strong and water-resistant, and can be used on any areas that will get wet frequently. The clear resins are good for transparent pieces. They are also suitable for mosaics in which you don't want to use cement mortar. A great many polyvinyl acetate resins are found at hardware stores under different trade names.

TILE MASTICS	There are two different types of tile mastics. One is for use on floors, and the other is for use on walls. These never dry hard and because they are water-resistant should be used for kitchen or bathroom mosaics. These adhesives are highly inflammable and set more quickly than most others.

CEMENT OR CONCRETE MIXES	Cement and concrete mixes are best used for outdoor pieces or large-scale mosaics. They can be bought ready-made in 60-pound sacks. Mortar mix contains sand and cement; you will have to add aggregate and water. Concrete mix contains sand, cement, and crushed rocks, and you need add only water.

There are, of course, many other kinds of glues and mortars that you can find which are intended for specific materials. Always remember that your tesserae should be cleaned (and your base as well) before applying *any* adhesive. Many times, dust, dirt, or grease will prevent the adhesive from working properly.

For wooden surfaces such as plywood, hardwood, fiberboard, or blockboard, use a damp rag. If you find that the surface is still too dirty, apply a coat of white primer or emulsion paint. The same is true of unfired pottery. For metal surfaces such as foil or tin, remove all the grease with acetone or gasoline. When working with glass, remove all grease with soapy water or acetone. Transparent synthetic materials should be cleaned only with soapy water, as chemicals will cloud their surfaces. It isn't necessary to clean off paper or cardboard surfaces with anything special. Just make sure that there is no dust or grit on any of the pieces.

ADHESIVES CHART

Adhesive	Properties	Use with
casein glue	not very water-resistant; dries transparent; nontoxic	porous or nonporous materials
white glue	water-soluble; dries clear; nontoxic	lightweight, porous or nonporous materials
library paste	water-soluble	paper and lightweight materials

epoxy resin glue	fast drying; water-proof and very strong	metals
contact cement	both waterproof and nonwaterproof varieties; highly flammable	nonporous surfaces
tile mastics	one type for walls and one for floors; never dries hard; water-resistant; fast drying and highly flammable	ceramic tiles, vinyl, or wood
mortar	concrete or cement; water and weather resistant	good for use with any outdoor material — slate, rocks, stones, and other nonporous tesserae
acrylic latex mixtures	mixable with mortar for additional binding power	holds pebbles and smooth stones well
resin & catalyst	transparent; waterproof	glass or acrylic plastic tesserae
waterglass	transparent; waterproof	
Japanese lacquer	transparent; waterproof	

BASES

Many found objects and pieces of furniture that might ordinarily be thrown out because they are too ugly or battered can be fixed up and made useful and colorful with a mosaic. Old tables, bookcase edges, cable spools, plain frames for pictures and mirrors, rusty plant boxes, and trays are just a few of the things you can lend new life to.

Beautifying objects with mosaics can make a personal statement about yourself. Instead of using what everybody else has, you have made something unique. Also, it's a lot cheaper than going out and buying the same thing or having it made for you.

Rocks, clay drain pipes, or the metal shapes and wooden boxes sold by hobby shops are forms that take mosaics well.

For other "start from scratch" mosaic bases, here is a list that should help you decide what is suitable for your project. The larger and heavier the finished piece, the thicker the base should be.

BASES FOR INDOOR PROJECTS

Tesserae	Suitable base material
papers	heavy cardboard, gray chipboard
seeds, snells, formica, vinyl	rigid ¼" masonite given two coats of shellac or waterproof seal
tiles of all sorts, stones, pebbles	unfinished plywood with two coats of water sealer: ½" for pieces under 2' square. ⅝" for pieces 2' to 14' square ¾" for pieces larger than 14' square larger pieces can be braced by diagonals on the back Novoply—a very strong composition board damaged hollow-core doors (excellent); these can be bought very cheaply
stained glass, plastic	lucite or plexiglass panels, double-strength window glass, plate glass
fabric	rigid masonite, lightweight wood

BASES FOR OUTDOOR PROJECTS

As previously mentioned, outdoor pieces have to be set in cement or mortar mixtures. A suitable frame should be constructed out of wood; then the mixture becomes the base and the adhesive at the same time. If the piece is over 2 feet square, then it should be reinforced by embedding a piece of metal screen or burlap in the middle of the mixture.

HOW TO MAKE A CONCRETE BASE

Concrete is an economical material to use for large mosaics. Not only does the concrete form the base, but it also becomes the adhesive at the same time. The problem with concrete is its weight. As a result, if you wish your mosaic to be portable, you shouldn't make it more than three feet square. If you wish to make a larger mosaic, it is best to divide the work into

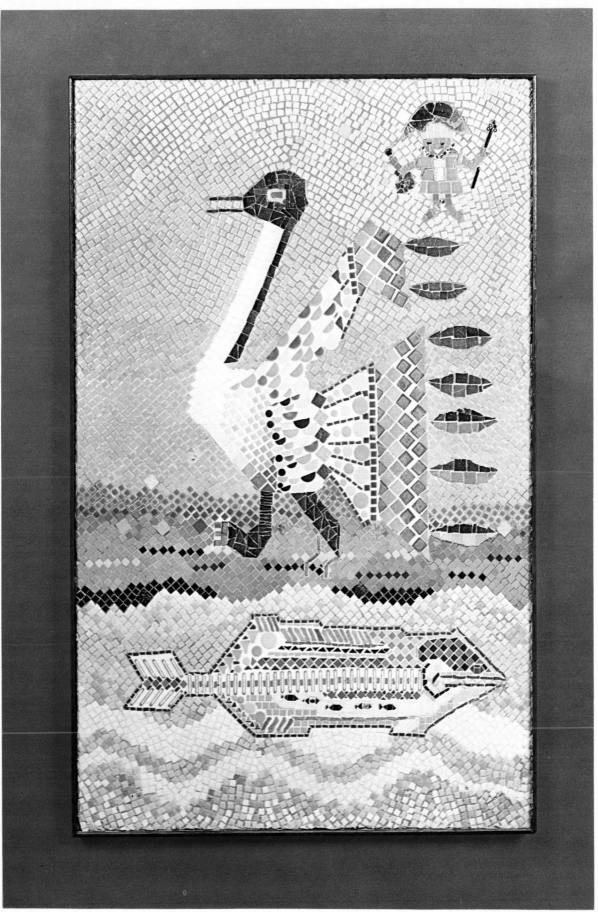

"Fish and Fowl" by Beatrice Lewis.

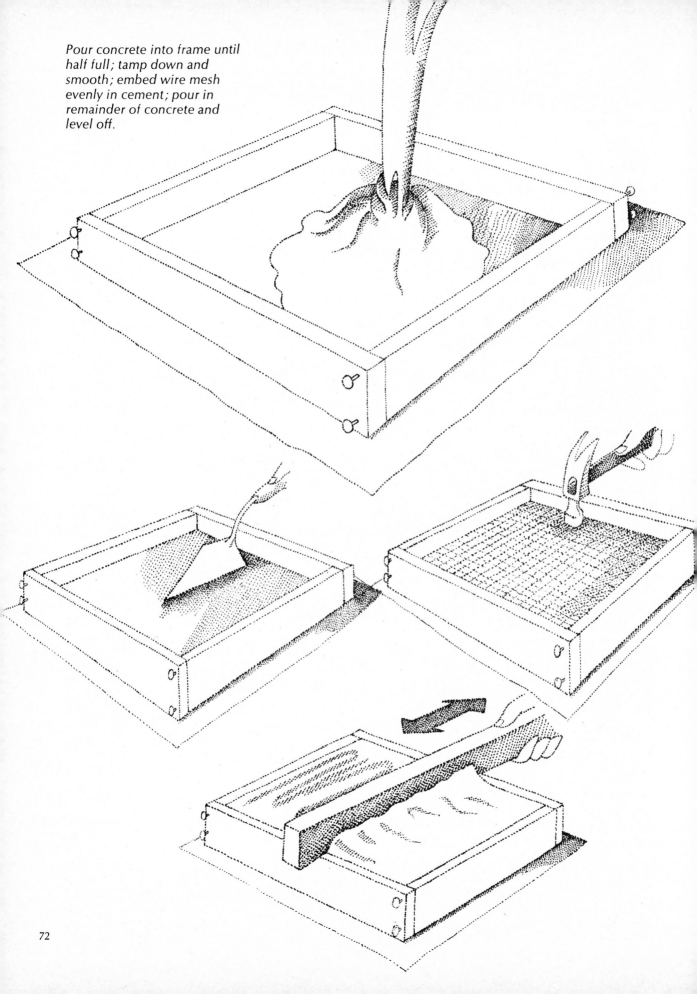

*Pour concrete into frame until
half full; tamp down and
smooth; embed wire mesh
evenly in cement; pour in
remainder of concrete and
level off.*

72

sections and put them together when complete. A lot of concrete squares or circles can make a beautiful patio floor.

Your concrete base can be shaped around a square or rectangular frame, or it can be made into an interesting free-form shape by using sand as a mold. The important thing about the frame you use to shape your base is that it should be easily removed when the concrete is thoroughly dry.

In order to make a rectangular frame for the base, you'll need the following tools and materials:

Four 2" x 2" pieces of lumber cut to size and notched or nailed
 together
Tar paper.
Metal screen or burlap
Wood float or steel trowel
Edging tool
Concrete mix
Sacking or plastic wrap

STEP ONE

Place the notched pieces of lumber together, or nail the pieces together leaving the heads of the nails sticking out slightly. This will allow you to remove the nails easily when it's time to remove the frame.

STEP TWO

Set the frame down on the tar paper and grease the inside surface with vaseline or any vegetable oil. This will prevent the concrete from adhering to the wood surface and allow you to remove the wood easily later.

STEP THREE

Cut your metal screen or burlap to size. If you use screening, make sure that it is flattened as much as possible. Do this by hitting it with a hammer on a flat surface. Set it next to your frame so that it will be right there when you are ready to place it into the cement.

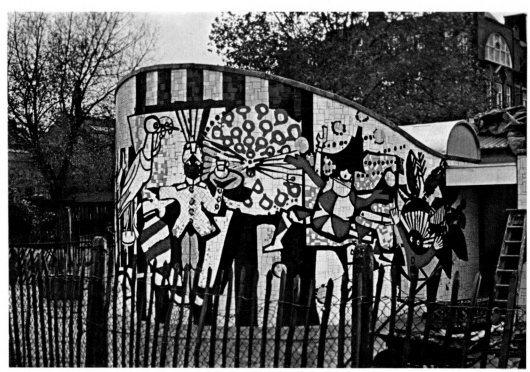

Fireworks and 18th-century toys are the theme of this huge (500 square feet) outdoor mosaic located in Vauxhall Gardens, England. Opposite page, top, work in progress; bottom, detail.

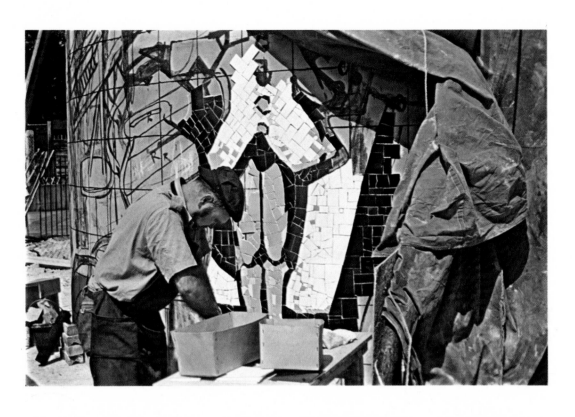

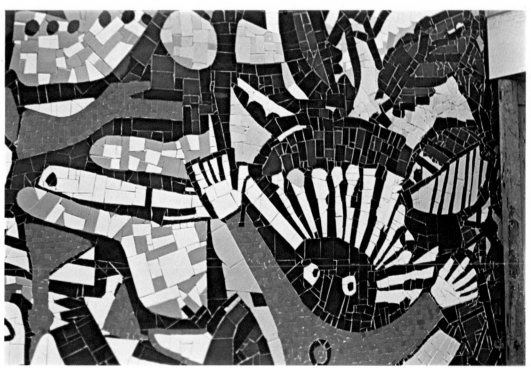

STEP FOUR

Mix the concrete and pour it into the frame until it is half full. Tamp it down well and trowel the surface until it is smooth. Make sure that the concrete goes all the way into the corners.

STEP FIVE

Place the wire mesh on top of this first layer of concrete. Hammer it into the cement until it is embedded evenly over the surface.

STEP SIX

Pour in the remainder of the concrete mix until the concrete is level with the top of the frame. Tamp it down well and smooth with the trowel or wood float.

STEP SEVEN

Start placing your tesserae in position. You have about two hours before the concrete starts to get noticeably hard, so it's best to have the pieces already laid out next to you. You have only to transfer the pieces and press them down into the concrete evenly.

STEP EIGHT

When all the pieces are in place, cover the concrete with damp sacking or plastic wrap and let it set slowly for about five days. At this point you can remove the frame and peel the tar paper off the back of the mosaic.

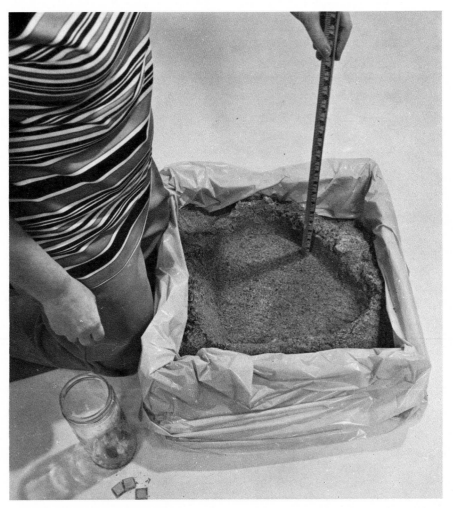

Sand mold ready for concrete.

This is quite a simple method and one by which you can make almost any shape you wish. Fill a box with damp sand, and then dig and smooth out a hole the shape of your base with a glass bottle. Pour the cement into the impression in the sand and smooth it down with a trowel. Place your tesserae in the concrete, pressing them gently down so they are firmly embedded in the mixture. Then allow it to cure slowly. (More about a variation on this method on page 171.)

CONCRETE BASES FREE-FORM

GROUTING

Remember that the interstices—the lines between the individual tesserae—are an important element in good mosaic design. One of the problems that accompanied the development of mosaic making was that its technical perfection heralded an artistic decline. As tesserae were made smaller and smaller (some smalti were as small as pin heads) and as artists learned more about color and perspective, they made mosaics with tesserae set so close together that the viewer could not tell that the work was not a painting. The mosaic was pretending that it was not a mosaic at all—a fatal untruth in art.

Grout is a white cement mixture that fills the spaces between the tesserae. It's not always necessary to fill up the cracks—some artists leave the rough spaces—but usually you will want to. Grouting gives the mosaic a solid, smooth surface. This is important when a completely smooth surface is desirable, as in bathrooms or kitchens, floors, trays, or countertops—surfaces that are going to be wiped off and cleaned constantly, and need to be smooth so that dirt does not get embedded in the cracks.

Many mosaics lose a lot of their vividness when grouted in white. Color can be introduced before the water is mixed into the grout powder. If you use color, pick a shade that will go well with the colors you have used in your mosaic. For example, if you have used pale-colored tiles, use a pale-colored grout such as beige or gray. Or you can use a color that will set off your tiles. If your tesserae are shades of red, an orange grout will complement them, or a dark brown grout will make them stand out. Again, your choice of color is a part of the design and should be thought about when you are planning your piece.

Powdered paint or dry mineral pigment works very well and should be well mixed with the dry grout before water is added. Always remember that the wet color is about three shades darker than it will be once it has dried. Marble dust or fine white sand is sometimes added to the grout. This gives it strength and also eliminates the risk of shrinkage.

Opposite page: Closely placed tesserae without grouting increase impression of solid color blocks in this mosaic design.

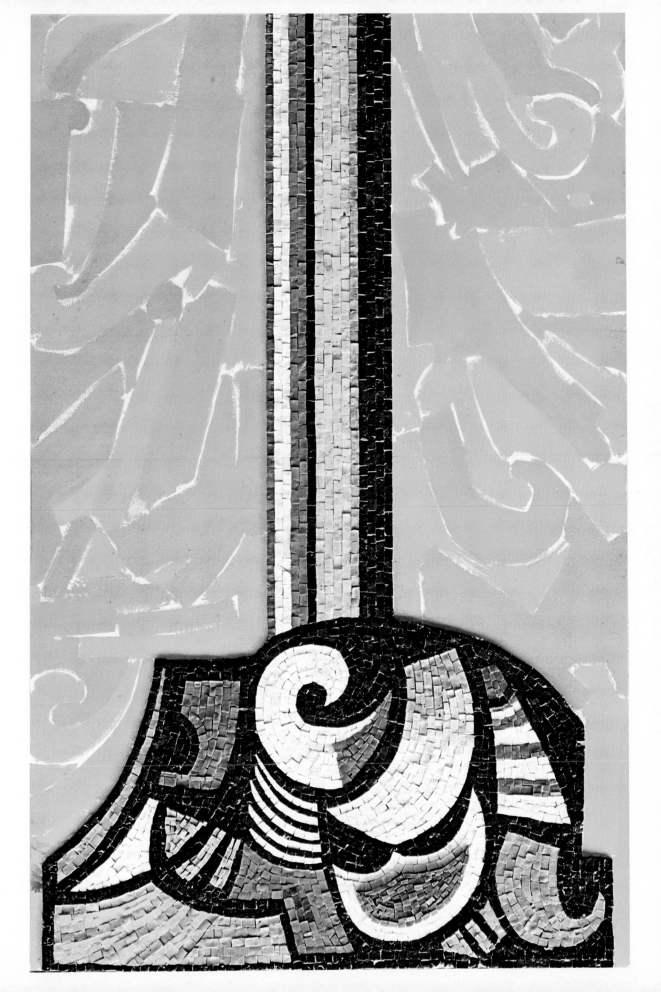

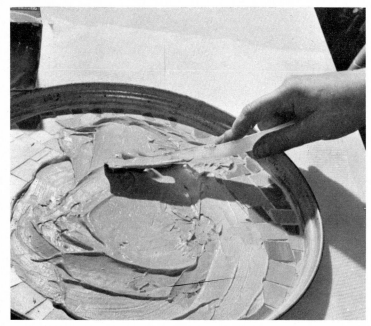

Spread grout with spatula (left);
work well into cracks (below).

WORKING WITH GROUT

You can make your own grout by adding one part lime putty to five parts Portland cement. However, it is usually easier when working with small- or medium-sized mosaics to buy ready-mixed grout in cans.

Mix the grout to a heavy-cream consistency and allow it to soak for about ten minutes. Then mix it again until it is smooth and creamy.

Apply the grout to the mosaic piece and rub it in well with a sponge, your finger, a spatula, or a squeegee. Allow it to set until it is firm to the touch (about 10 to 15 minutes). Remove excess grout with a damp cloth or a damp sponge. Don't let the grout set—dry up—on the face of the tesserae.

Clean and polish the piece with a clean, dry cloth after about an hour.

If the weather is damp and moist, allow at least 48 hours for initial set before using or hanging. The curing process goes on for about ten days before it is completed. During that time, wet the grout from time to time—this improves the curing.

It is important to clean the grout from the tiles. Bits of grout will dull your tesserae and make the piece look messy. A sponge should do the trick, or for more difficult bits you can use a pick, always being careful not to scratch the tesserae.

You might have bits of adhesive as well as grout adhering to your surface. Try soap and water and a knife to remove the pieces of adhesive. If this doesn't work, use benzine. If you still have adhesive that won't come off, use a 10% solution of hydrochloric acid. But be careful with this solution, and wear rubber gloves to protect your hands; also, keep your gloved hands from touching any part of your skin or clothing.

Try to remove all the adhesive from your piece before grouting if you are using hydrochloric acid. If you have used a colored grout, the acid will leach out the color.

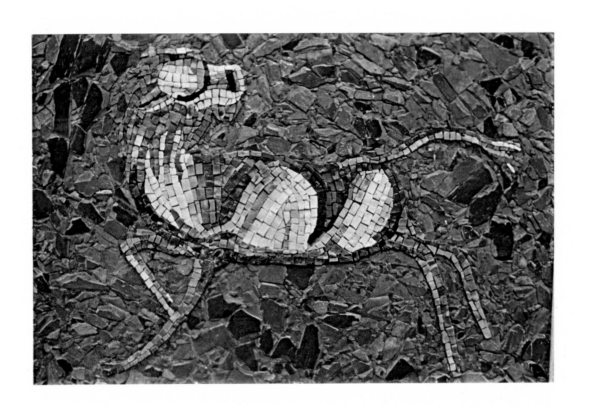

5
Techniques and Methods

You used your imagination and your sense of color and design in choosing your project; now it's time to call on your sense of order and organization.

Making a mosaic requires a certain amount of preparation and the mastering of a few simple techniques. One important thing is to get your tesserae ready.

Whether you buy them or make them, you will have to make sure that they are a workable size. Most tile, glass, or smalti pieces come in standard sizes. For large-scale works, this size may be quite all right. However, the tesserae for smaller or very detailed mosaics usually require a certain amount of cutting. The mosaic tiles usually chip and fly around, so if possible, work outside. And do wear goggles.

No matter what kind of tesserae you use, with the exception of rocks or pebbles, they are all relatively soft. The major problem you'll run into is the tedium involved in cutting each tessera until you have enough to complete your mosaic. Check against your cartoon—lay the tesserae out on top of your design—when you think you have cut enough, because it's difficult to stop in the middle of your work and start nipping at tiles.

There are several methods for placing tesserae into the adhesive. Study the section on methods carefully, because each method will give a different effect, and this is an integral part of the design of your piece.

TECHNIQUES

TILE CUTTING

Hold a tessera between the thumb and forefinger, thumb up. Hold the cutter in your working hand—again, thumb on top. Now open the cutter and position the tile at right angles about ⅛" into the "bite" of the tile nippers. Don't place the tile entirely inside the blades; the tessera will shatter when you start to cut. Cup your free hand around the cutter and tile; squeeze the cutter firmly to grip the tile; press hard. The tessera will break, leaving two parts in your hand. Practice this technique before starting on an intricate work.

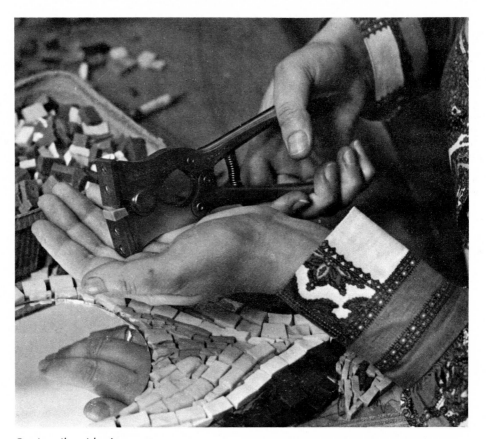

Cutting tile with nippers.

Glass cutters do not actually cut glass. They weaken it, so that a sharp tap will break it at the weak point.

Hold the cutting wheel so that it sits comfortably in your hand and draw it perpendicularly to the piece of glass. Press into the glass until the moving cutter "bites" the glass. After you have scored the glass, turn it over and use the ball end of the cutter to tap it. Usually the break will be clean. If you are cutting a large shape and the glass tends to move, fasten it down with plasticine clay or florists' clay.

It is far easier to cut straight edges than curves, but if a rounded shape is required, do it in sections as suggested by the diagram.

GLASS CUTTING

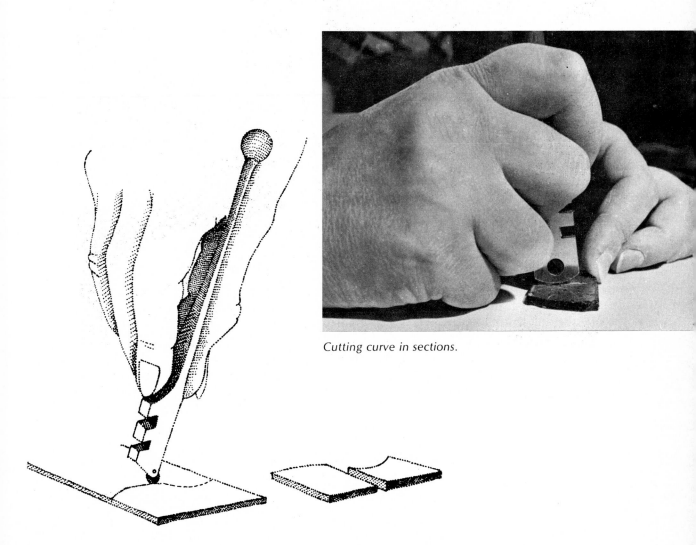

Cutting curve in sections.

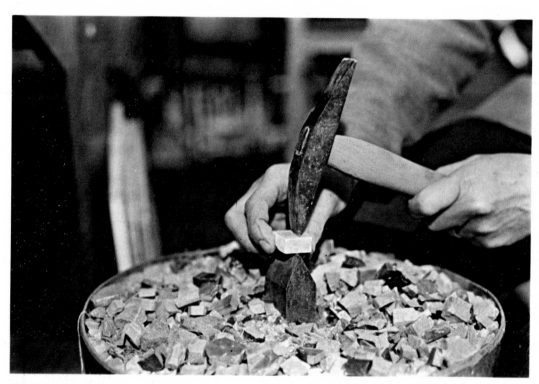

Cutting smalti with hammer and hardie.

SMALTI CUTTING

The best way of cutting smalti as well as marble or stone tesserae is with a mosaic hammer and a hardie. A hardie—a sort of square-shanked chisel or fuller that fits into a base—can be bought at a mosaic supply house, hobby shop, junkyard, or wherever forges are sold. A mosaic hammer can be found in the same places or at a sculpture supply house, or a brickmason's hammer can be used.

A tree log can serve as a base for the hardie. Not only can it be cut to the right height to sit at, but it is easy to wedge the hardie into the wood to keep it from sliding when you hit the smalti with the hammer. If you don't have a log, you can embed the hardie in a can filled with cement or plaster.

Hold the smalti at right angles to the hardie blade and hit it with a quick, light touch with the hammer. This method takes a great deal of practice, as any tenseness or wobbliness in the wrist will shatter the piece.

You can also cut smalti with a tile nipper, but only if the smalti is less than ¼″ thick.

POUNDING GLASS AND POTTERY SHARDS

If you work with irregularly shaped pieces of old glass or ceramic pottery, a simple method of getting the large pieces down to a workable size is to place the pieces between the folds of a newspaper or magazine and hit them with the flat side of a mallet or hammer. Make sure you wear your goggles during this process, and don't pick up any of the sharp pieces without gloves.

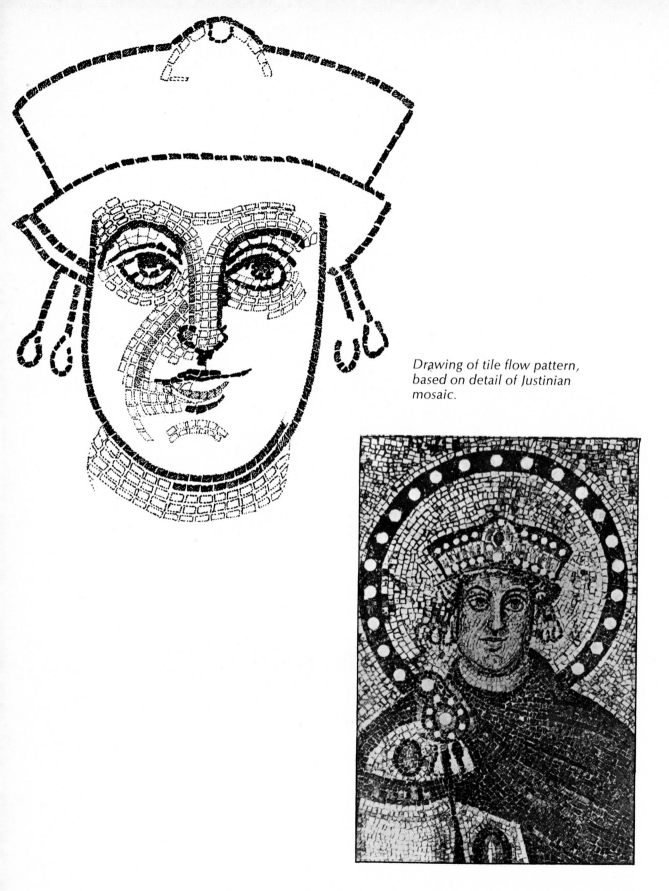

Drawing of tile flow pattern, based on detail of Justinian mosaic.

METHODS

PLACEMENT OF THE TESSERAE

A certain amount of thought has to go into the placement of the tesserae because placement will create a flow in your design if done properly. Perhaps it wouldn't hurt to examine carefully a few ancient and modern mosaics to get an idea of the direction of the mosaic pieces. This flow and direction will help suggest the form you are doing.

The placement of the tesserae should follow the contours of the form. When you are doing a figure or animal, there are forms within the outline of the body; if you divide each of these parts up and have your tesserae follow the contours of each area, you will achieve a three-dimensional quality in your work. If you are making a face, it is best to start with the eyes and follow their contour until you reach the cheeks. Follow that contour until you reach the vicinity of the nose and then follow *that* contour. Each area will be well defined, but separate and distinct from the ones next to it. If you were to set the whole face with all the tesserae going in an oval following the outline of the head, the effect would be quite flat.

Lay out your tesserae on a sheet of paper before starting so that you can plan your design before actually setting them into the adhesive. This way you will also see whether you have to make minor adjustments in the size of certain pieces to make them fit closely. You will find that it's much easier to change your mind about placement *before* the tesserae are stuck in the adhesive.

Once you have your mosaic laid out, there are two methods for setting your pieces into the adhesive: the direct method and the indirect method.

THE DIRECT METHOD

The direct method is the oldest of the mosaic methods. It wasn't until large-scale mosaics began to be commissioned in the 13th century that the indirect method was used. It is also the most uncomplicated method because of its basic straightforwardness. "Direct," in this particular application, is quite apt.

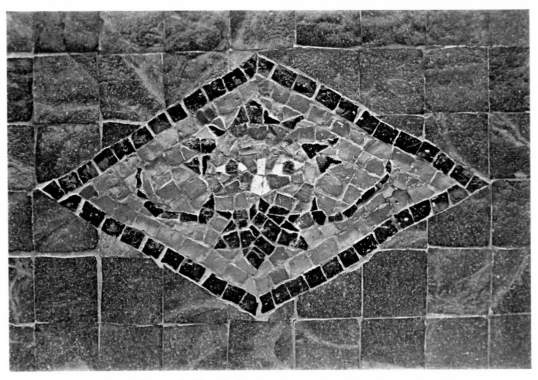

Contemporary mosaic echoes primitive design patterns.

In the direct method, each piece of mosaic is set by hand into the adhesive. Leave a narrow space between each piece if you intend to grout, but if not, try to set them as close together as possible. Each tessera can be individually buttered with the adhesive and then placed directly on the base, or you can spread the adhesive over a small area of the base and set in several pieces at a time. With either approach, it is best to have your cartoon right next to the base as a guide for color and direction. You can lay all the pieces out on the cartoon just the way you want them to appear in the mosaic and then simply transfer each piece to the base.

Once the pieces are laid into the adhesive, give them a light tap with a small-headed hammer to make sure they are set in solidly.

One of the most exciting effects of the direct method is that you achieve a bumpy surface which reflects light and makes the entire piece shimmer. Of course, there are certain

instances where you would prefer a perfectly smooth surface. In this case, you should use tesserae that are all uniform thickness and press them down evenly all over the mosaic.

When you use the direct method, it is a simple matter to draw your cartoon right on the base and work directly on that. You can also, for variety, make your cartoon on the base and color it in exactly the way you wish the colors to appear. Use an oil-base paint, and when it is completely dry, apply a thin layer of a clear adhesive. This way, when you place your tesserae on the painted areas, the color will show through the cracks. In this case there is no need to grout your work. If you use clear glass tesserae, you will get an even more exciting effect.

In the indirect method, the design of the tesserae is completely set out on a sheet the exact size of the final work. When you are happy with the design, spread water-soluble white glue over a piece of heavy paper or muslin (cheesecloth) and place it over the design. Pat it down to make sure all the pieces are stuck to the paper. Allow it to dry completely. When dry, flip it over onto a board so that the wrong

THE INDIRECT METHOD

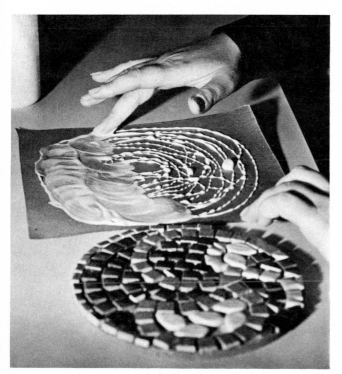

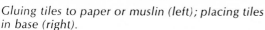
Gluing tiles to paper or muslin (left); placing tiles in base (right).

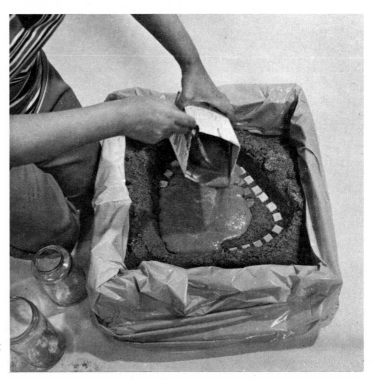

Pouring mortar into hollowed-out sand form.

side of the tesserae is now up. Pour your adhesive into the form or base and reverse the glued design onto the adhesive. When the adhesive is dry, moisten the paper or cheesecloth thoroughly and peel it away.

There are two advantages to this second method. First, the surface of the mosaic is even. This is necessary for work surfaces that will be washed often, or surfaces such as coffee tables where you don't want things to be off balance and possibly fall over. The other advantage is that you can easily correct your design when it is laid out on the paper. In addition, when working on very large mosaics, the design can be divided into squares on a grid system, and each section can be set out separately and then transferred to the base with ease.

The important thing is to use water-soluble glue in the first step, and make sure that the adhesive you are using on the base isn't water-soluble at all. Otherwise, when you attempt to peel the paper or cheesecloth off the tesserae, you will end up ungluing the tesserae from the base as well.

A new approach to the indirect method is provided by the development of "contact" paper. Instead of using water-soluble glue and paper or cheesecloth in the first step, you can simply lay out your design and then remove the protective backing from the contact paper and lay it carefully on the surface of the tiles. This means that you can use the indirect method when you are working with water-soluble adhesives. Always remember that contact paper is very, very sticky, so it is often difficult to work with in large pieces. If your mosaic is large, you can cut smaller pieces of contact paper and lay them on the tiles next to one another and achieve the same effect.

ANOTHER METHOD

Certain materials are going to end up bumpy and irregular whether you use the direct or the indirect method. For example, pebbles and stones are never going to come in uniform thicknesses or shapes. In order to achieve a smooth surface with these irregularly shaped pieces, make a form of hollowed-out sand or use a commercial shape. (If you use a commercial shape, make sure that you grease the sides and bottom well with vaseline or vegetable oil first.) Place the tesserae in the bottom of the form "company side down." Then, gently pour the cement or mortar onto the pieces until you have filled the form to the depth you want. Always pour gently because if you pour too quickly, you might displace the pieces. When the adhesive is set, remove the form and wipe off the pieces. For a specific project using this method, see the stepping stones on page 170.

REFLECTED LIGHT

One of the problems you will face is that of reflected light. In any mosaic, because of the nature of the materials, light will be reflected from each single piece in the work. With the indirect method, the pieces are flat and reflect light in only one direction. With the direct method, the pieces can be tilted at many different angles. There is always a risk of achieving glare instead of a rhythmical reflection of light.

One way to vary light reflection is to tilt each tessera in different portions of the mosaic in one direction. Once you have placed all the tesserae in the wet adhesive, take a pick or

Tilting tile edge into adhesive.

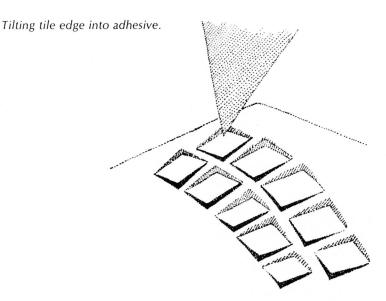

other pointed object and press one side of the tile deeper into the adhesive than the other side. Do this with each piece, but always tilting the same side down. You can do the tilting to enhance contours in the design, or you can tilt entire areas of color in one direction, but don't try to achieve both effects at the same time.

Of course, if you are trying to create movement and depth within a solid color area, you can tilt some parts in one direction and some in others. Then, as you move around the mosaic, the colors will change and almost dance before your eyes. You can achieve quite a few optical illusions by proper use of this technique, and the best way to master it is to practice first on a few small experimental mosaics.

Opposite page: Closely placed eggshell pieces tinted in all colors of the spectrum were used to make this extremely realistic mosaic.

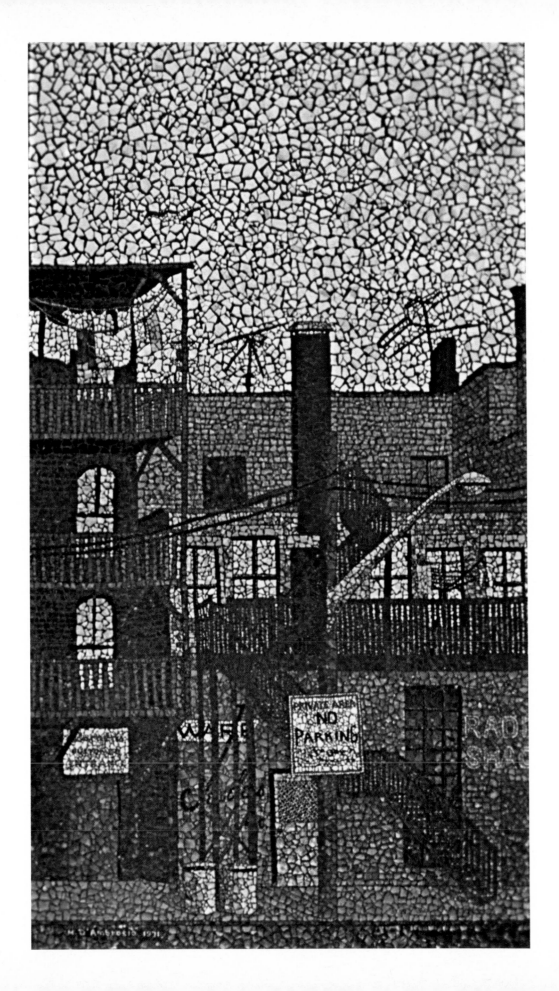

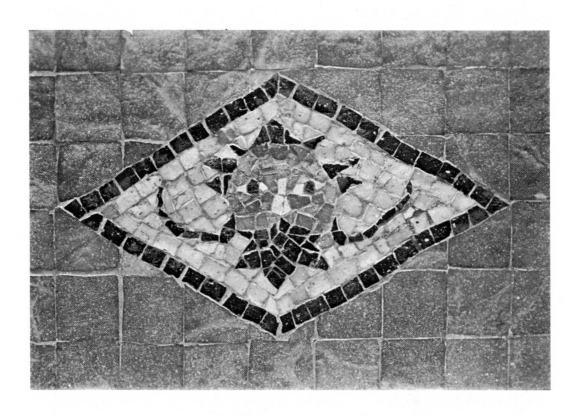

6

Framing and Hanging Your Mosaic

Not all pieces need to be framed. Some, such as bought trivet bases, trays, or coffee tables that have raised edges, will have ready-made frames. If you have a mosaic piece that you wish to frame, however, there are many different ways of doing it.

Some pieces look very attractive when they are edged with tiles or pebbles like the ones used in the mosaic itself, or with a different type of tesserae. This is especially simple when working with a wood base. Simply spread adhesive along one edge at a time and lay the tesserae end to end. Make sure you do the top edge last if your hanging device is located on the top. Then it won't get in the way when you're doing the bottom edge.

You can also make a frame out of wood stripping or veneer that has been given two coats of varnish and a waxing. If you are planning to grout your piece, the frame should be attached after the adhesive is dry, but before the grout is applied. Cut the stripping to size and after you have applied your finish to the wood, glue it to the edges of the base with a strong epoxy cement. If your base is wooden, you can also nail it to the base with small brads. Before applying the grout, cover the edges of the frame with masking tape to protect them. After the grout has dried, you can peel off the tape.

If you plan ahead, you can buy a frame, and then have your base cut to size so that it will fit into the ready-made frame. If this is what you decide to do, make sure that the frame is strong enough to hold up your completed mosaic. If necessary, you can always reinforce the corners of the frame by screwing small "L" brackets onto the back of the frame at the four joins.

FRAMING

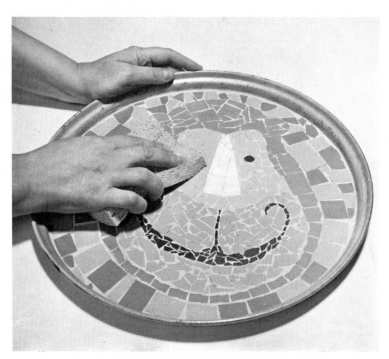

Objects with raised edges (left, below) or silhouettes (right) should never be framed.

98

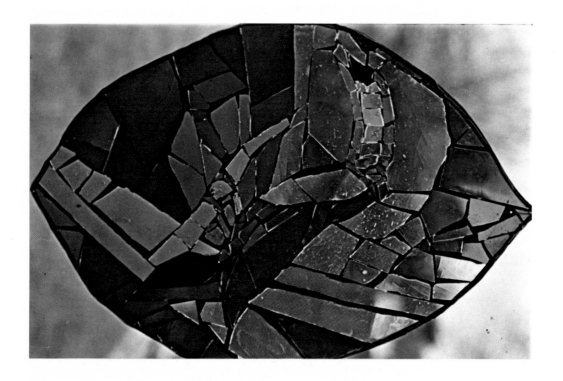

Brass edging makes a handsome frame and should be attached with brass tacks or screws. You can use a hammer and anvil to shape the stripping to your mosaic. Wrap the hammer head with a rag so that you don't mar the brass. If your piece is round, you can solder the ends together to hold it to your base. In some cases the brass may tarnish, so if it hasn't been sealed by the factory, polish it well and give it a coating of clear lacquer spray.

You can also use the soft plastic edging that is generally seen as molding on kitchen cabinets or counter tops. This is best for curved or round bases because it will take and hold the shape easily. Warm it up before bending it. This will prevent it from cracking. This molding can be glued on with tile mastic or epoxy glues.

Again, always remember to put your frame on *before* you grout, and always protect the frame with masking tape so it won't get soiled by the grout mixture.

Put in hook for hanging before gluing on side tiles.

HANGING

Mosaics are, by nature of the materials used and because of the heavy-duty bases on which they are made, quite weighty. As a result, if you expect to hang one on a wall, you are going to have to use heavy-duty hangers. These can be bought, or they can be made by you and incorporated into your base.

If you have used a heavy-duty bought frame, a mirror specialty store can supply you with the heavy-duty wire and holders that are used on the frames. Make sure that your wall is strong enough, or locate the two-by-fours in the wall by banging it with your fist until you hear a solid sound.

If your wall is made of plaster, the best thing to use as a hanging device is a toggle bolt. Drill a hole in the wall, unscrew the toggle wings, and push the toggle screw through the mirror bracket. Screw the toggle wings back on the screw. Holding the two halves of the toggle together, push it through

Heavy pieces such as this pebble wall hanging need screw holes.

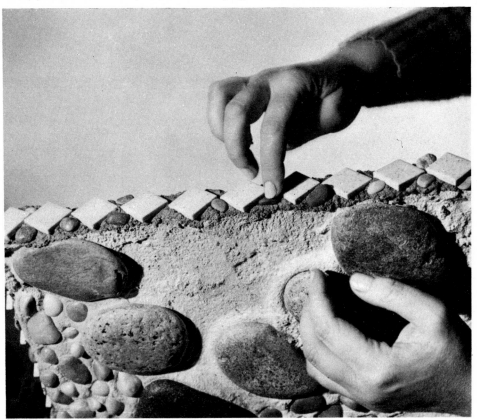

the hole. When the toggle is completely through the hole, the wings will open on the other side automatically. Then, pull the toggle tight against the inside of the wall and screw with a screwdriver.

If your mosaic is concrete based and is not going to have a frame that will support it, you have to build the hanging devices right into the base itself. First, locate the two-by-fours in the wall where you intend to hang the piece. Having found them, mark the distance on your mosaic base frame. At these points, drill holes and insert greased metal tubes or wooden dowels about ¾″ in diameter. When you pour the concrete, these holes will remain free, and you will be able to insert screws through. Otherwise, once the concrete has hardened, there would be no way to attach a strong hanging device to your piece.

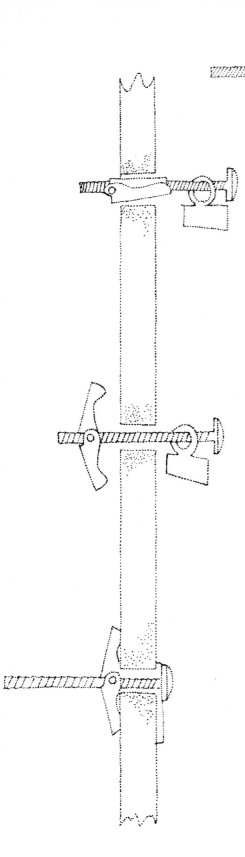

Push toggle through hole; after
wings open on other side, pull
bolt towards yourself (so that
wings are pressed against inside
wall) and screw in.

Insert greased dowel before
pouring concrete to make hole
for hanging device.

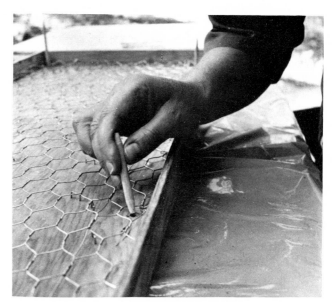

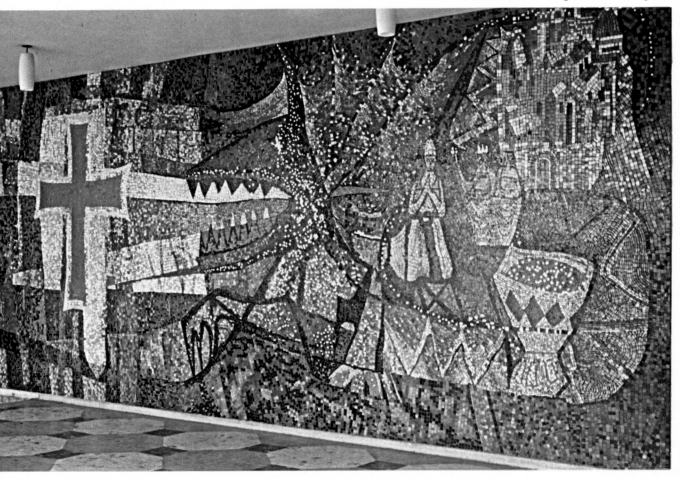

Make sure that the tubes extend through both the wire mesh and the base itself. Now proceed with the mosaic, pouring the concrete and placing the tesserae. When the mosaic is completely set and the concrete has been allowed to cure slowly under its cover of dampened cloth or loose plastic, remove the tubes. The holes can now be used to hold the long screws or toggle bolts to fasten the piece to the wall.

The exact type of screw you use will depend on the composition of the wall. There are butterfly screws and Molly bolts as well as toggle bolts. These are all for heavy-duty hangings,

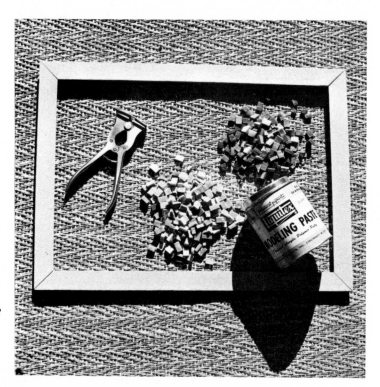

Right: Light, ready-made frame can be hung with a range of traditional devices. Below: To hang a tray, insert wire loop before pouring mortar.

so check with your hardware store for the type that will work best.

For smaller, lightweight pieces, you can attach a traditional hook-and-eye device to the top of the frame. These hangers are usually rings attached to a screw base that can easily be screwed into a piece of wood such as plywood. If you wish to

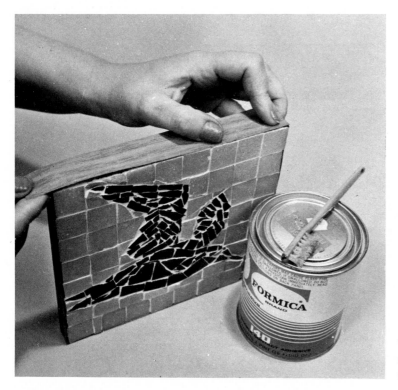

Wood veneer framing cannot support the weight of even light pieces.

put a hanging device on the back of a tray that you are going to mosaic, punch a hole through the tray near the top, and attach the ring device with a nut that will hold it tight. Then you can pour your adhesive into the tray, and it will cover the bolt. If the bolt is too long, snip off the end with a strong pliers.

Another method for hanging a tray is to punch a hole in the top of the lip and insert a loop of wire through the hole. Extend the wire down so that it forms a corresponding, larger loop in the tray itself. When the mortar is poured into the tray, it hides the loop and holds it firmly to the base. Also, the wire will reinforce the mortar in much the same way that the screening and burlap reinforce concrete bases. The loop which remains outside the tray forms the hanger.

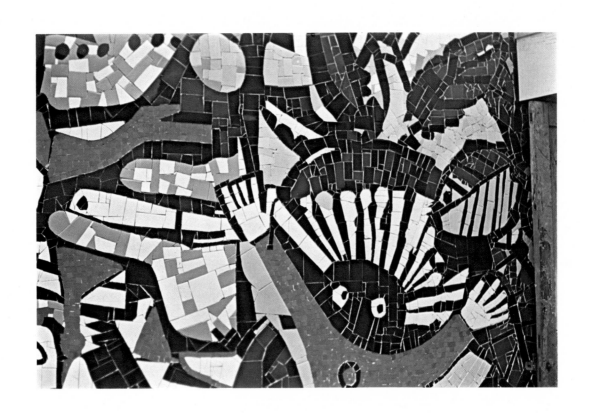

7
Seventeen Mosaic Projects

Trivet set in hobby shop form
Pebble wall hanging
Decorative mirror frame
Trinket box lid
Snack tray
Children's tray
Notice board frame
Bottle stoppers
 Sea glass stopper
 Pebble stopper
 Elath stone stopper
Acrylic table top, mosaic
Plywood trivet
Stained glass mosaic
Medallions
Seed mosaics
Resin trivet or window hanging
Free-form steppingstones
Eggshell mosaics
Vacation home hearth

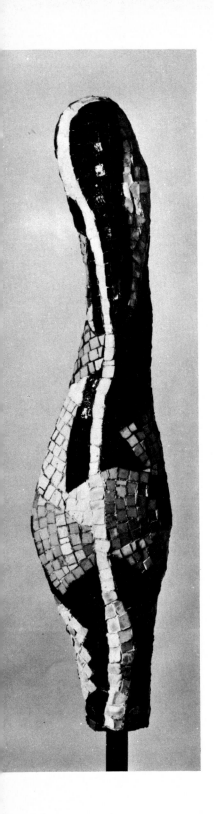

Seventeen
Mosaic Projects

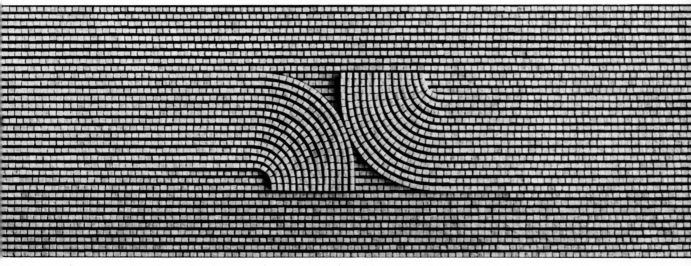

Black grout contrasts with white marble tesserae—a central design element.

Let's look at various projects you can make, starting with the simple ones and going on to the more complex. However, you must remember that each is merely a jumping-off point, a place to start. You don't necessarily have to make these things exactly the way we present them. You can make your own decisions about design, which tesserae to use, and what you will use as a base. Each project will simply give you an idea of how to proceed when using the different methods and materials, and provide you with some practice if you aren't already familiar with mosaic making. We hope that, once familiar with all the techniques, you will use our suggestions merely as a guide.

The emphasis in these projects is on smaller objects that are basically household items. They are meant to be lived with. As a result, color choice is entirely up to you. This way, your exact needs can be filled. You don't have to make every project—just those that you need or want.

You can also use the things you make as gifts. As not all mosaics have to be functional in the everyday sense, any of the designs we include can be used as wall hangings or window decorations. Although mosaic making can be one of the more expensive hobbies, it can also be one of the cheapest if you wish to use unusual materials. The intention of this section is to introduce you to a satisfying and exciting way of expressing yourself, and we hope that the ideas that begin here will be followed by more and more ventures into design and creativity.

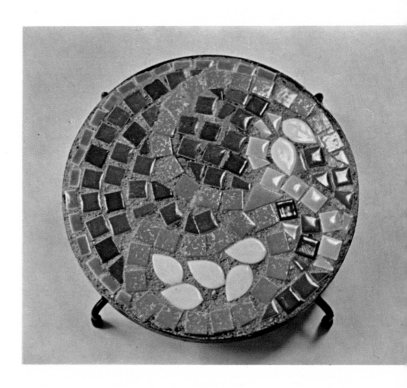

Trivet Set in Hobby Shop Form

MATERIALS AND TOOLS

Tesserae: smalti
Base: trivet bottom
Adhesive: mortar; epoxy (just in case)
heavy paper, water-soluble glue

tweezers
tile nippers
small putty knife
rolling pin
soft rags

A trivet is very useful, and you can make it more interesting and personal with your own mosaic design. The indirect method was used in this piece. There was no preconceived design; the base was removed from the frame, and the colors and shapes were moved around on it until a pleasing design was arrived at.

Use your tile nippers to cut any tiles that need to be shaped to fit. When this design was almost finished, tweezers and a toothpick helped adjust the tesserae to the correct angles.

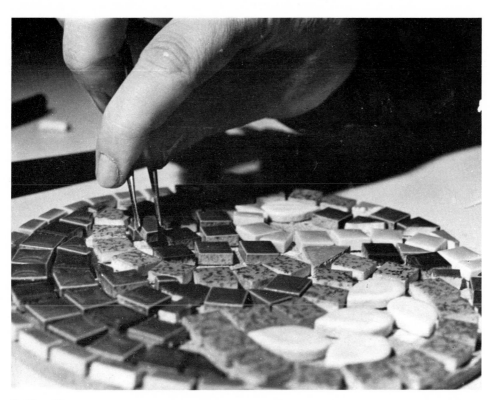

Setting tile.

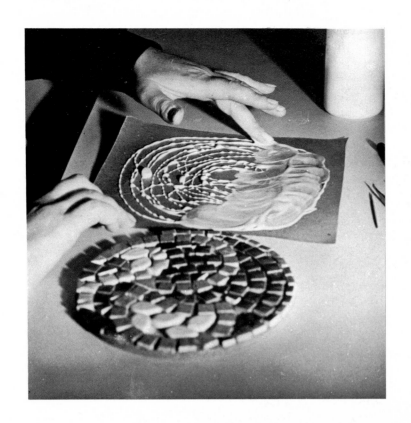

Gluing paper (above); pressing paper on design.

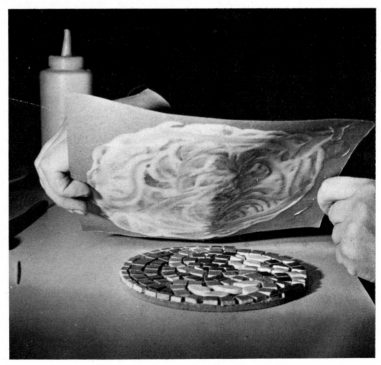

A piece of heavy-duty paper cut slightly larger than the size of the trivet base was then smeared with water-soluble glue.

The paper was placed glue side down onto the mosaic design and patted to make sure that each tile was in contact with the paper.

When the glue was dry, the paper was lifted off the base with the tiles stuck firmly to it and laid aside.

The base was then placed back in the trivet stand and filled three-quarters full with mortar. The surface was smoothed with a small putty knife.

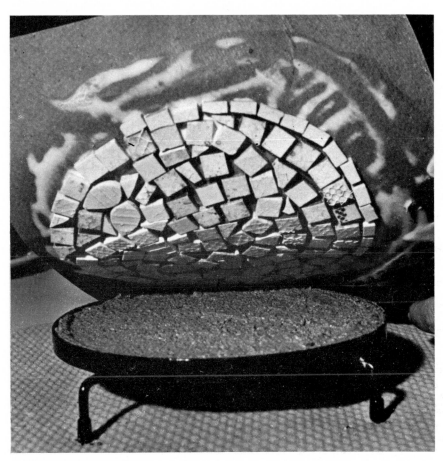

Putting tiles back in base.

Pressing tiles on to mortar bed.

The tiles, still stuck to the piece of paper, were lowered onto the mortar bed and pressed gently all over—a rolling pin or mallet can be used if necessary.

Covered, the piece dried for a few hours. Then the paper was dampened and peeled off. A couple of detached tiles were replaced with epoxy cement. The surface of the tiles was cleaned with a soft rag, and then the piece was allowed to cure for several days.

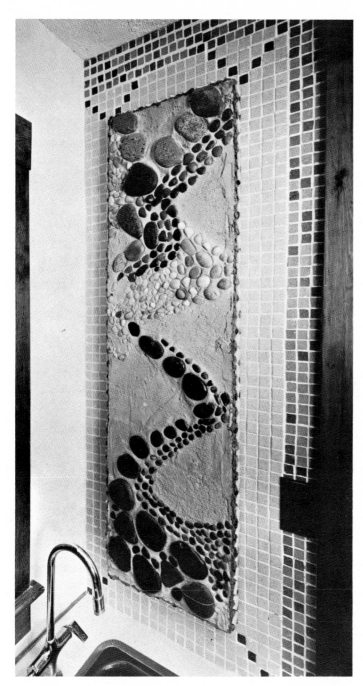

Pebble
Wall Hanging

Tesserae: pebbles and stones
Base: ¾'' exterior plywood, 4' x 18''
Frame: 4'' wood stripping
Adhesive: natural colored mortar and cement bonding adhesive (acrylic latex)
galvanized chicken wire
heavy-duty stapler
six 6'' wooden dowels
six butterfly Mollys for hanging
clear spray lacquer

trowel
piece of wood
plastic wrap

115

This mosaic was made to fill an awkward space where there wasn't enough room to work directly on the wall. The piece was to be viewed from one side only, so the curves in the design were elongated. The foreshortening which was a result of the viewing angle turned them into gentler curves, once hung. The design was inspired by the Maine sea coast, so the pebbles and stones were especially appropriate to the theme. This piece demands a rather large work area, so find a good spot before you begin.

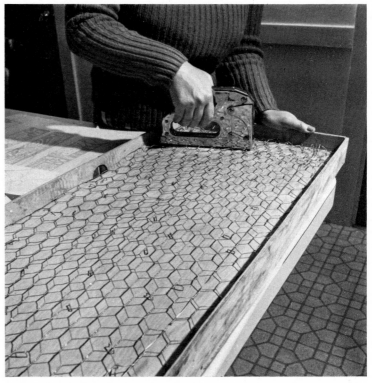

Staple chicken wire into frame.

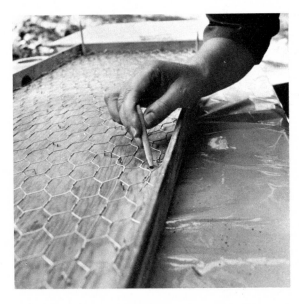

Left: Insert dowel to make hole for hanging device. Bottom: Lay out pieces on cartoon.

The base, cut to size from ¾" exterior ply-wood, was temporarily framed with a wooden edge made of stripping. This gave the base a lip of about 3". Heavy-duty staples were then shot into the wood every few inches. The galvanized chicken wire to reinforce the mortar was then stapled into the frame. The staples embedded in the wood elevate the chicken wire and keep it away from the base, so the mortar can fill in all the areas.

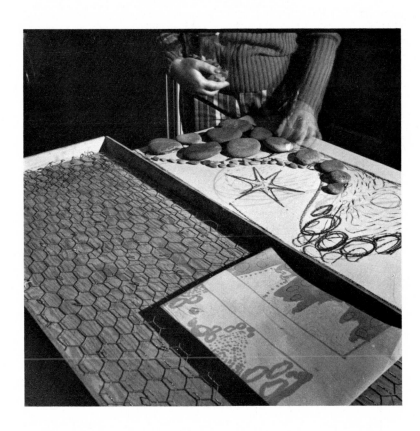

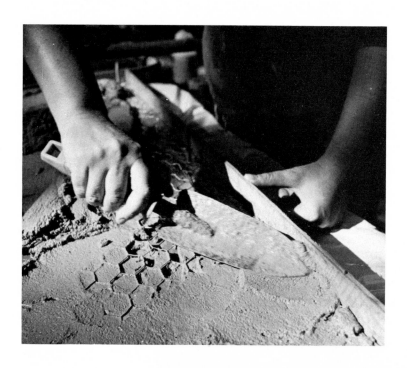

*Work mortar into spaces
beneath chicken wire and
smooth with piece of wood.*

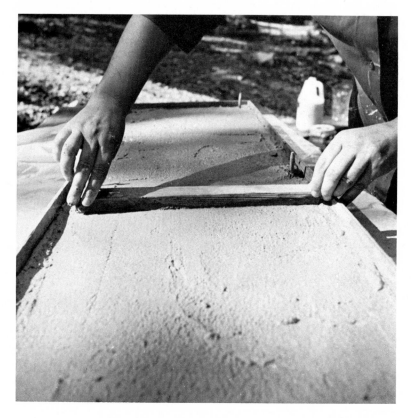

Six holes are drilled into the base and plugged with the sharpened, greased dowels. These holes will provide the space for inserting the butterfly Mollys to hang the finished piece to the wall.

The design is laid out on a cartoon beside the frame. Now is the time to select the pebbles. Plot the whole piece on the cartoon, just the way you want the finished mural to look.

Cement bonding adhesive is now added to the mortar mix and troweled into the frame. Be careful not to disturb the dowel plugs.

Smooth the mortar with a piece of wood.

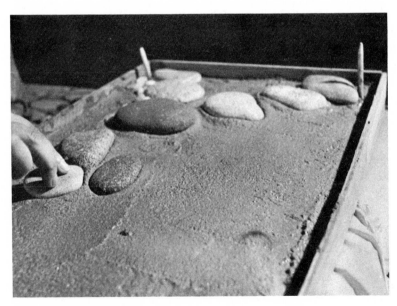

Place pebbles in position.

Place the pebbles into position quickly, without altering their position once in the mortar. The working life of the mortar is about 30 minutes—that's why it pays to be sure of your design.

Wrap the mosaic in wet burlap for 26 to 36 hours. Do not use a nonporous cover. The initial set is within four hours. Wash all your tools in water quickly after use.

When the piece is dry, remove the tem-

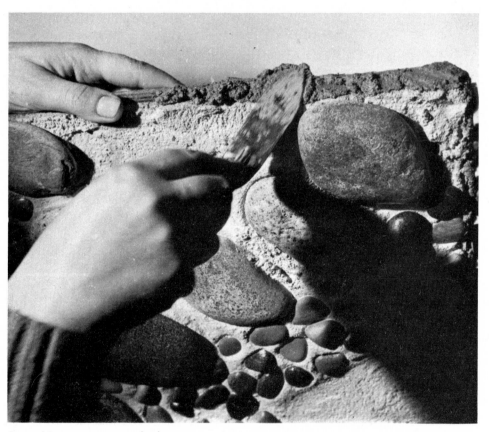

Smoothing mortar around edges.

porary frame and spray the pebbles with clear lacquer. This enhances the natural coloring and beauty of the stones. The dark pebbles become darker, and the light pebbles become brighter.

A piece made this way can be framed with a wooden frame or, as here, framed with stones or tiles set into mortar in a decorative pattern.

To frame the piece, put additional mortar around the edges with a trowel.

Set your frame tiles in place.

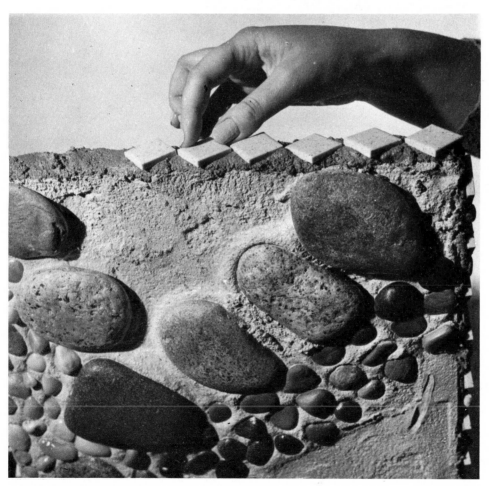

Position frame tiles.

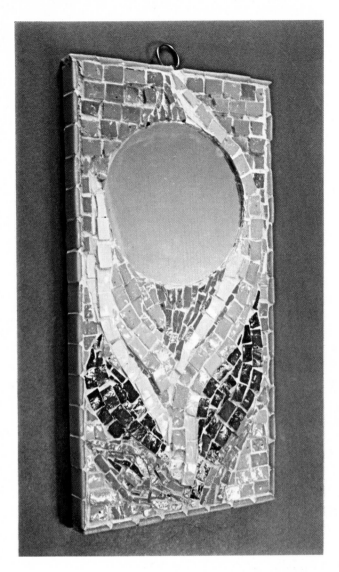

Decorative
Mirror Frame

**MATERIALS
AND TOOLS**

Tesserae: smalti
Base: ⅜'' plywood
Adhesive: casein glue
pigment
grout
round mirror
double-stick carpet tape or sealing wax
cardboard
felt
hanging device
spatula for grouting
toothbrush
carboloid-tipped tile nippers
tweezers
soft rags

A piece of ⅜″ plywood cut to size forms the base of this piece. The mirror is stuck on with the double-stick tape used for carpets—or with sealing wax, if you can't find the tape. Some adhesives will spoil the silvered backing of the mirror, so if you want to use something else, experiment on an old pocket mirror first, or inquire at your local hardware store.

A pair of carboloid-tipped tile nippers is used to cut the smalti into the sizes you want to work with.

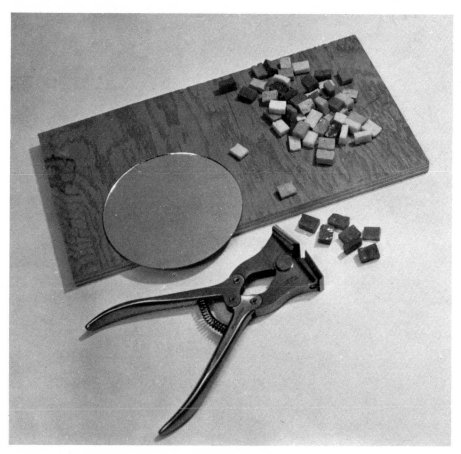

First step: Cut plywood and tiles to approximate size.

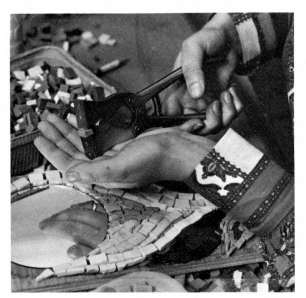
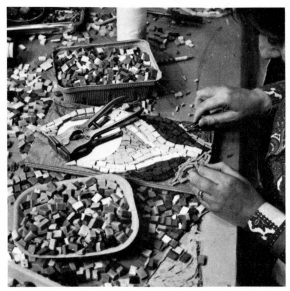

Cut smaller tiles; position tiles with tweezers (right).

Draw your design onto the base. Spread the glue on the base, a small area at a time, or "butter" each piece with it. Using the direct method, just set in the tesserae. You can work from a cartoon or just decide which colors you want where as you go along. Tweezers will help in adjusting hard-to-get-at spots.

Frame the piece by gluing tesserae along the side edges of the wood. Frame one side at a time. Make sure you do the top edge last so that the hanging device doesn't get in the way when you do the bottom edge.

When the mortar is dry, cover the mirror with a piece of cardboard. Mix the dry pigment with the grout and follow the package directions. Spread on the grout with a spatula and let it set. Then clean it off with a soft rag (a toothbrush will help to get at those hard-to-reach places). Now the piece is ready for use.

The back of this piece was covered with bright orange felt to add a "finishing touch."

Generally speaking, smalti are best left ungrouted (like the notice board frame on page 139). Another method of doing this piece would be to set it in reverse and then grout it before setting it into the mortar.

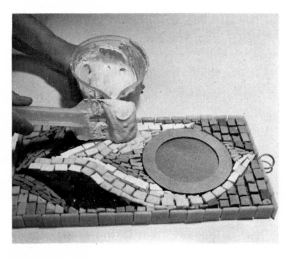

Spreading grout (above); placing frame tiles (left).

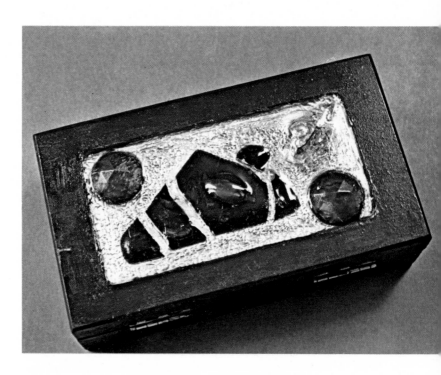

Trinket Box Lid

**MATERIALS
AND TOOLS**

Tesserae: broken or melted colored glass
Base: wooden jewelry box
Adhesive: resin

tin foil
white glue
stain or paint
sandpaper
wood sealer
plastic cup

a nail
tweezers

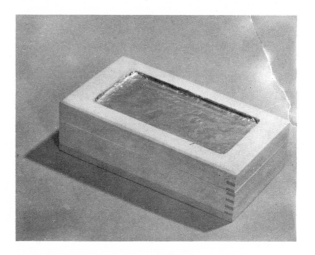

An unfinished wooden jewelry box bought at a craft supply store—or any old wooden box for that matter—can make an unusual setting for a mosaic.

A piece of medium-weight tin foil is glued into the depression with white glue.

The pieces of fractured melted glass or other found glass are arranged in a pleasing design on the surface of the foil.

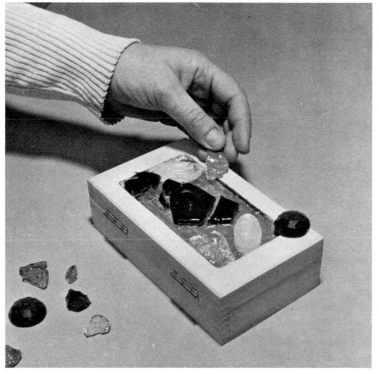

Foil glued to box top (above); arranging glass tiles (left).

Tool the area around the glass pieces you have laid down with the blunt head of the nail. This not only decorates the foil; it shows you the position of each piece of glass. Do this before the glue under the foil has completely dried—and do press gently.

Remove the pieces, then stain or paint the wood. A plastic sandwich bag will protect your hands.

Mix the clear resin or catalyst in a plastic cup according to the directions. Don't use a styrofoam cup because the chemicals will eat into it. Pour a small amount onto the area and place the pieces back in position with tweezers. Then drip more resin on to cover the sharp edges.

Tooling glass pieces.

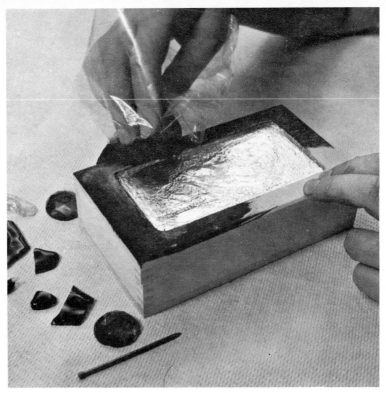

Staining wood top.

Let the piece cure until it is completely hard. Don't touch it until the suggested time interval on the can of resin has passed; otherwise the surface will be marred.

Lightly sand the wood and seal it with lacquer or whatever finish you desire. The inside of the box can be lined with velvet, felt, or corduroy. Choose a color for the lining that matches or contrasts with the outside.

Placing pieces with tweezer.

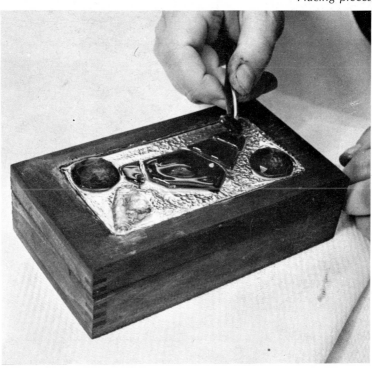

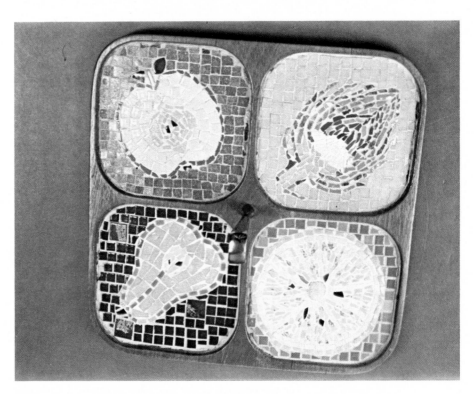

Snack Tray

MATERIALS AND TOOLS

Tesserae: ceramic tiles
Base: tray
Adhesive: white glue
grout
silicone sealer

tile nippers
spatula
soft rags

This teak tray had been soaked in a flooded basement, and its owner thought it was completely ruined. Boasting a ceramic mosaic, the tray once again became an attractive, useful item.

The design for each segment was chosen from fruits and vegetables that had been cut in half. The design was then drawn onto the base.

The ceramic tiles were cut to coincide with the feeling and texture of the particular fruit or vegetable and then glued into position with white glue, using the direct method. You can lay the pieces out on paper and then transfer them, or just put them down without the aid of a pattern.

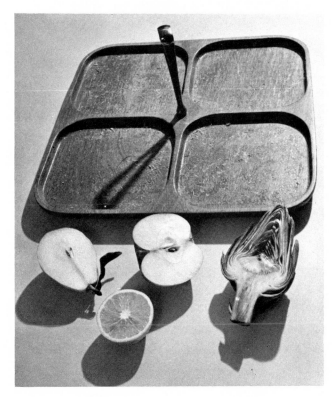

Tray and vegetables for design.

Add a contrasting background, using tesserae that are all the same shape. The regularity of the shapes and the single, solid color make the design stand out.

When the glue is quite dry, mix the grout according to the package instructions and smooth it on with a kitchen spatula. Remove the excess after 15 minutes. Two hours later, polish the piece with a soft cloth and seal it with silicone sealer. It takes about 10 days for the piece to cure completely.

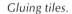

Gluing tiles.

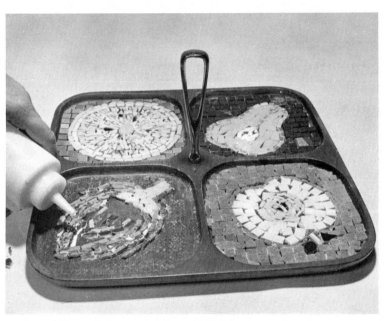

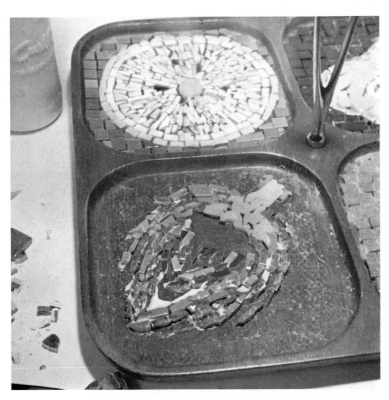

Contrasting background will
emphasize design (left); tray ready
for curing (below).

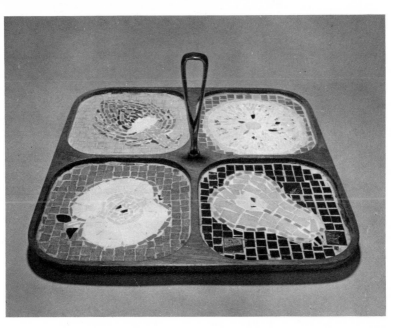

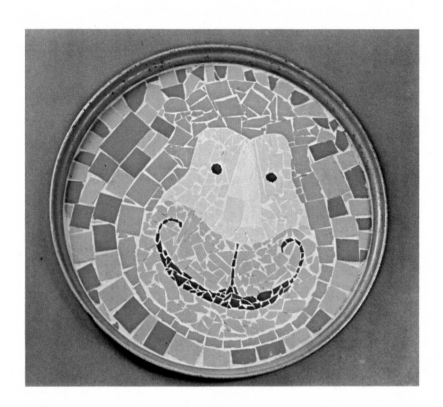

Children's Tray

MATERIALS AND TOOLS

Tesserae: formica
Base: round tray
Adhesive: white glue

heavy paper
carbon paper
soft pencil or china marking pen
grout
pigment
silicone sealer

tile nippers (or Bema cutter)
spatula
sponge
soft cloth

Trace around the shape of the tray on sturdy paper and cut it out. Draw your cartoon. Then transfer the design onto the tray with carbon paper. You may have to go over the carbon lines with a very soft pencil or a china marking pen to make them stand out clearly.

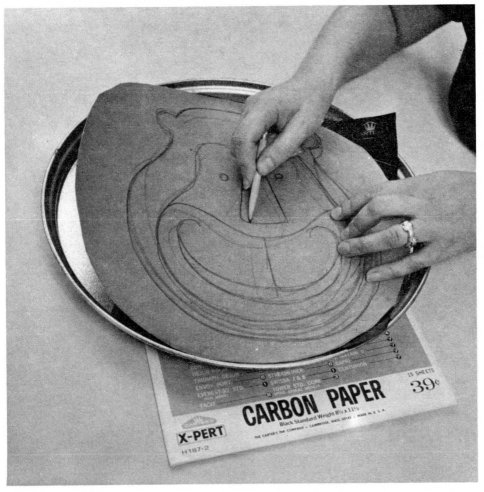

Drawing cartoon.

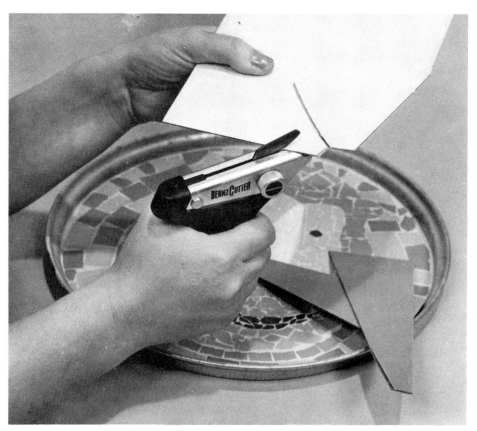

Cutting formica with Bema cutter.

Cut the formica with the Bema cutter and then set the tesserae into position so that the pieces follow the contours of the design and glue.

When the pieces are all set in and the glue is dry, mix the dry pigment with the dry grout and follow the package directions. The grouting is done in two stages because one color grout is used for the face and another is used for the background. After you have mixed the two batches, smooth grout on the face first and on the background next with a kitchen spatula.

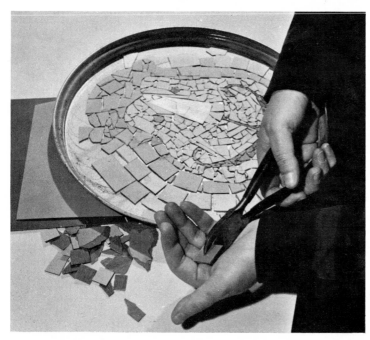

Cutting smaller tiles.

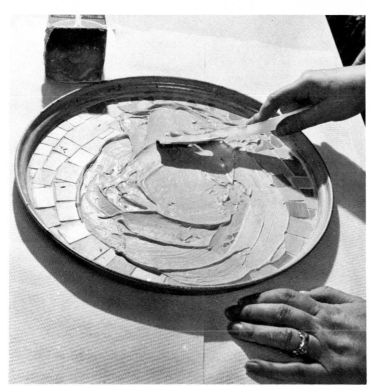

Smoothing grout.

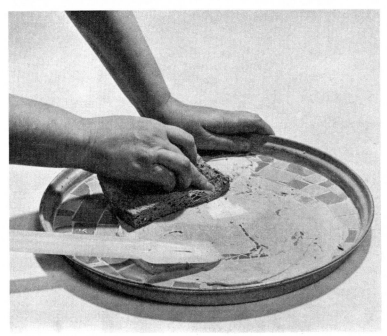

Wiping off excess grout.

Polishing and sealing.

Allow the grout to set for 15 minutes; then wipe off the excess with the spatula or a sponge.

After about two hours, polish the piece with a soft cloth.

When completely dry, seal it with silicone sealer to make it waterproof

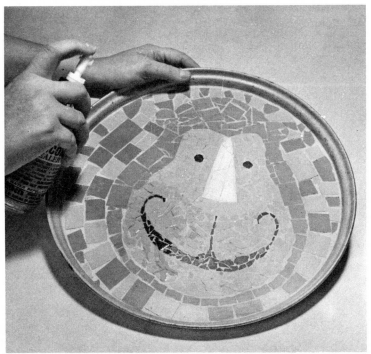

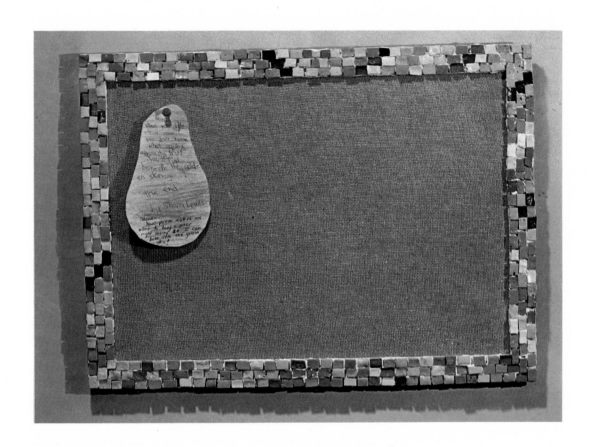

Notice Board Frame

**MATERIALS
AND TOOLS**

Tesserae: smalti
Base: picture frame
Adhesive: acrylic polymer putty

spray paint
fine sandpaper
homosote

tile nippers
small pick

A plain frame can be turned into a colorful border for a notice board. The "depth" edges are first sprayed with a color that is complementary to the colors of your tesserae.

Check the tiles to make sure they are all the right size. If any need cutting, do it now. When you use anything but a random design, you have to be careful at the corners. Play around with several arrangements to make sure the tiles will join at the corners.

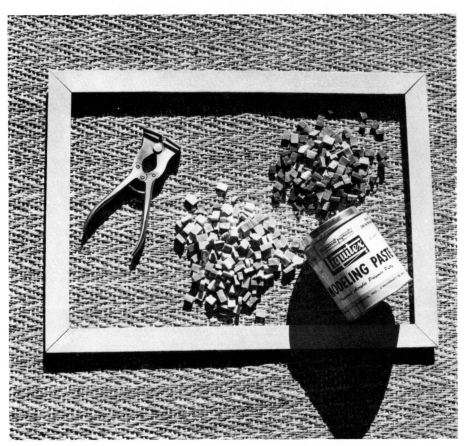

Frame and materials.

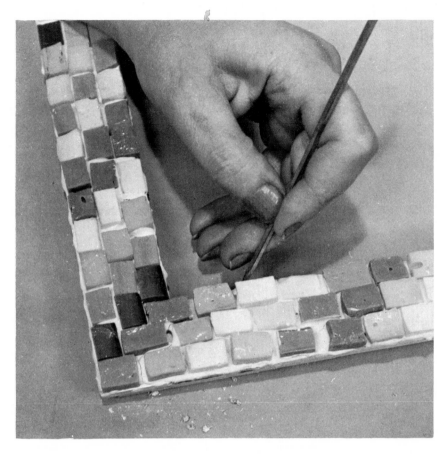

Putting tiles on frame.

Cover small areas of the frame with the putty, and put the tiles into place. This type of adhesive, if put on thickly, eliminates the need to grout later on.

When the cement has dried, scrape the excess off the edges with a pick or sand it smooth.

A piece of homosote painted to contrast or match, or covered with fabric, is then inserted into the frame.

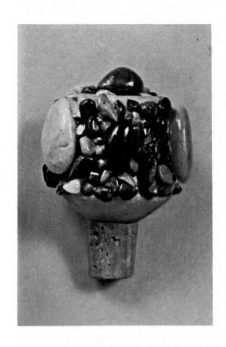

Bottle Stoppers

Bottle stoppers embellished with mosaics can add a unique and striking note to your kitchen or bar. A child's wooden block, an acrylic cylinder, a knob, or an old stopper can be used as a base. The tesserae can be any combination of materials that strikes your fancy—not excluding dried legumes or citrus peelings! One word of caution if you are using a cylindrical base: Do one side at a time and allow it to dry before you continue.

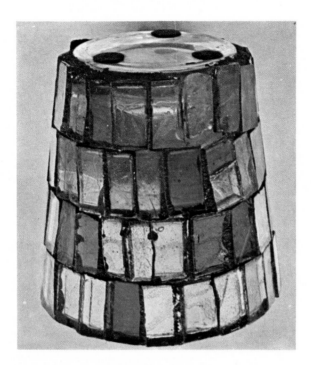

Sea Glass Stopper

MATERIALS AND TOOLS

Tesserae: glass smoothed by the ocean and cut blue glass tiles
Base: plastic pharmaceutical pill bottle
Adhesive: clear silicone adhesive
cork
resin and catalyst
small bottle
plastic cup
stone or brass disk

tweezers
toothpick

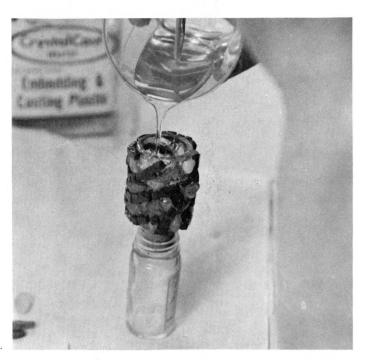

Filling cylinder with resin.

The cylindrical base used here is reminiscent of ancient columns in Italy. First, glue the cork into the bottom of the plastic cylinder, and then glue the tesserae into position in contrasting spirals of color.

When the design on the sides is completed, stand the stopper up in a small bottle to dry.

When the adhesive is dry, fill the cylinder three-fourths full with the resin and drop pieces of colored glass into it.

When the cylinder is full, drip resin over the outside to round off the sharp edges.

When this is dry, an interesting stone can be glued to the top and covered with more drops of resin. The top can also be left smooth or covered with a brass disk.

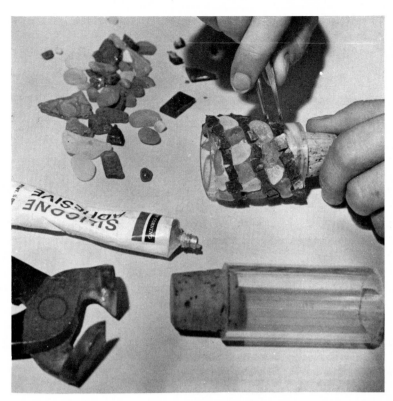

Gluing tiles to side (left); gluing stones to top (below).

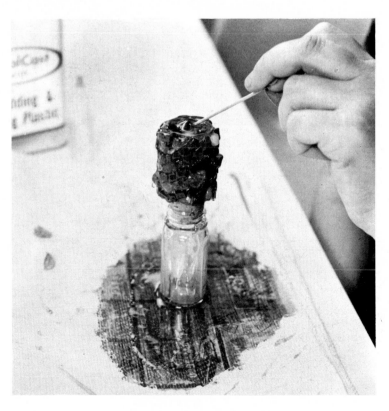

Pebble Stopper

Tesserae: Sea pebbles and melted opaque glass
Base: anything
Adhesive: clear silicone adhesive
grout
pigment
cork
silicone spray

toothbrush
soft rag

Glue the cork onto the base, place the sea pebbles on it in an interesting pattern, and allow it to dry thoroughly. Use pieces of melted opaque glass here and there for accent.

Mix pigment with the grout to give it some color and then apply the grout with your fingers. Gently remove the excess grout after 15 minutes.

After the grout has set for one hour, clean the stopper with an old toothbrush. Twelve hours later, when it is completely dry, wipe away any smears with a soft rag.

Seal with silicone spray so that the stopper won't absorb any stains.

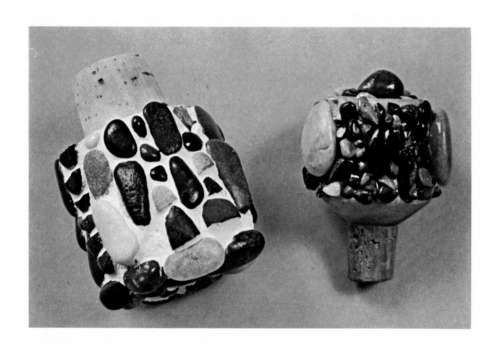

Elath Stone Stopper

Tesserae: semiprecious Elath stones and pebbles
Base: old wooden stopper
Adhesive: white glue
cork
silicone spray

rock tumbler
tweezers

**MATERIALS
AND TOOLS**

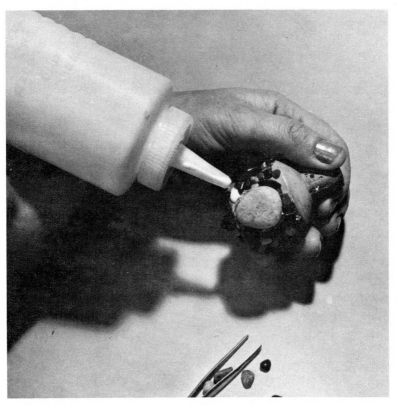

Gluing tesserae.

The semiprecious pieces of Elath stone were tumbled for several days in a rock tumbler until they became smooth and their lovely green peacock colors showed their beauty.

The cork was glued onto the base and the tesserae were glued down with white glue in a "regularly irregular" design.

Small pieces were positioned with tweezers.

The glue was allowed to set and then the stopper was sprayed with silicone spray to seal it.

The smoothed pebbles feel pleasant to the touch and the design is different from all angles.

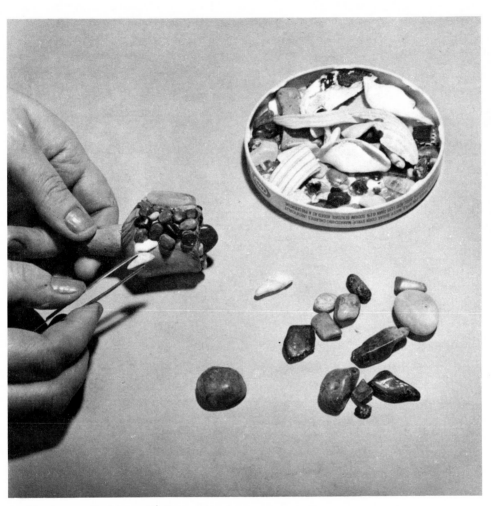

Positioning small pieces with tweezer.

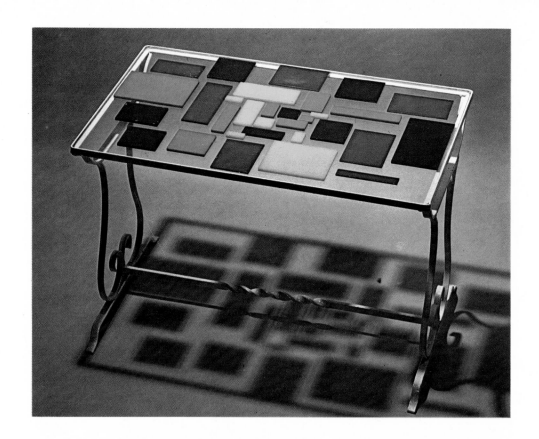

Acrylic Table Top, Mosaic

MATERIALS AND TOOLS

Tesserae: scrap acrylic plastic
Base: acrylic plastic sheet, 16" x 32"
Adhesive: acrylic bonding agent (purchased where you got the plastic)
emery paper
dry cleansing powder or a very fine abrasive

radial arm or bench saw with metal cutting blade or special acrylic cutting tool
pencil
hypodermic needle or special acrylic applicator
ruler
absorbent rag
soft flannel cloth
electric buffer (in place of fine abrasive)
a heavy weight

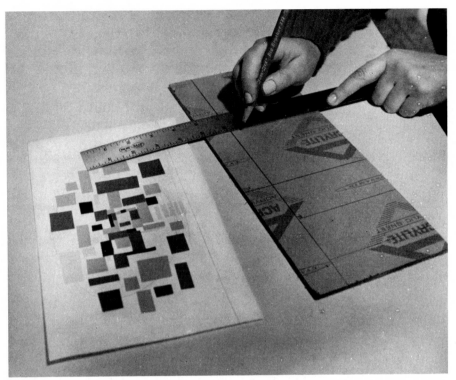

Drawing cutting lines.

A wrought-iron table minus its top, bought at a country auction, plus scrap opaque plastic, which is sold by the pound, plus a little ingenuity were transformed into this attractive piece.

Acrylic plastic is sold with both sides covered with paper; this should not be removed before cutting because it keeps the edges from having a sawtoothed look and also protects the plastic from smears and scratches.

Decide on your design and then work directly on the pieces or enlarge the design to size to avoid the aggravation of scaling the pieces up.

To make the tesserae, draw your cutting lines carefully on the papered surface.

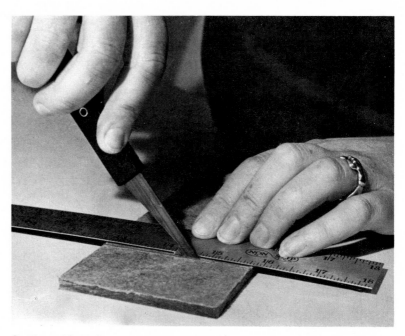

Cutting with tool.

Cut these, using a radial arm or bench saw with a metal cutting blade. If you are using acrylics that are about ⅛″ thick, there is a cutting tool sold especially for this purpose.

Peel the paper off one side of each piece, including the base, and set out the design on the surface. Make sure the unpeeled side of the base is up.

The pieces you finally select should be carefully checked for rough edges. If they need any smoothing, sand them down with emery paper. Clean all the dust from the table top and the pieces, and place these tesserae one piece at a time (peeled side down) on the table surface, and weight them down. This will eliminate air bubbles.

Experiment with the applicator or hypodermic needle and bonding agent before working directly on the piece. It seals with capillary action and dries very quickly, so you have to follow the directions on the can to the letter. Apply the bonding agent very carefully and keep an absorbent rag nearby to wipe up any stray drops immediately, or else they will mar the surface.

Making design (top); weighting pieces and applying acrylic (bottom).

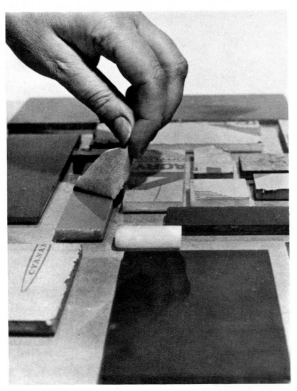

When all the pieces are bonded in position, peel off the top papers.

Turn the table top over so the design glows through from below.

Polish any slight scratches with dry cleansing powder or very fine abrasive on a soft flannel cloth. You can also use an electric buffing wheel, which requires less elbow grease.

Peel off top paper (above); turn table top over (right).

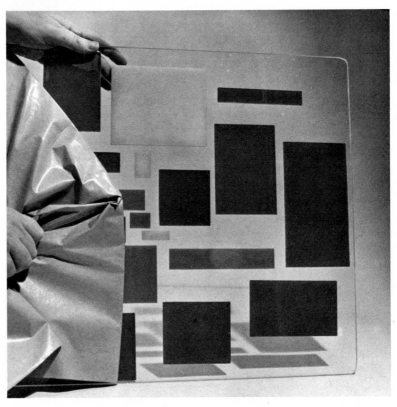

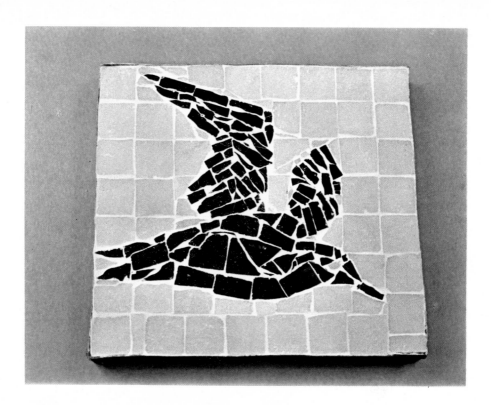

Plywood Trivet

MATERIALS AND TOOLS

Tesserae: black and cream-colored glass tiles
Base: ½″ plywood cut to size
Adhesive: white glue

carbon paper
paint
grout (optional)
pigment
wood veneer
contact cement
paper and pencil
silicone sealer
linseed oil
rubber no-slip disks or felt dots

spatula
soft cloth
paintbrush
damp sponge
razor
tile nippers

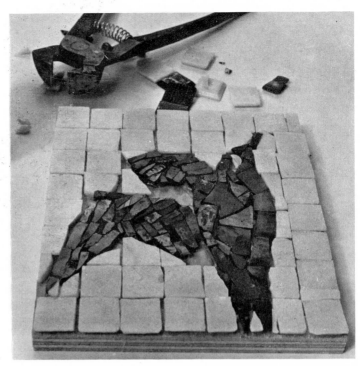

Position tiles and glue down.

Draw your design directly on the wood or do it on a piece of paper and then transfer it with carbon paper.

If you do not wish to grout the piece, then paint the wood with a background color that will work with the finished colors. Even your glue can be colored with tempera paint.

Position your tiles and glue them down. Any tiles that need changing can be cut with the tile nippers.

When the glue has completely dried, mix the grout and pigment and follow the package directions. Apply it to the piece with a spatula.

Next, rub the grout in with your fingers to make sure it gets into all the spaces.

After about 35 minutes, remove the extra grout. A few hours later, the remaining traces should be removed with a damp sponge. When the grout is completely dry (about 12 hours later), polish the faint smears of grout off with a soft rag.

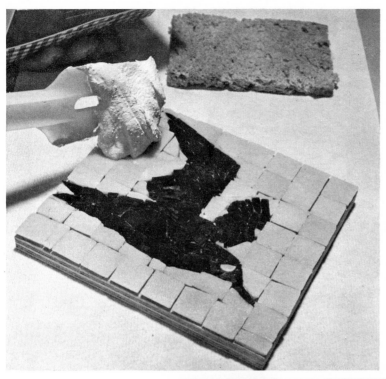

Spread grout with spatula (left);
rub grout in with fingers (below).

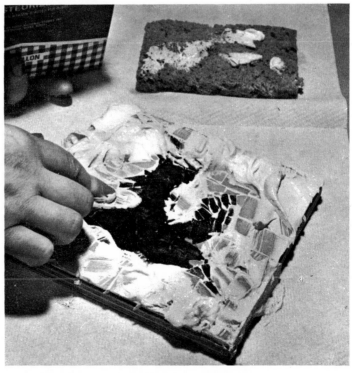

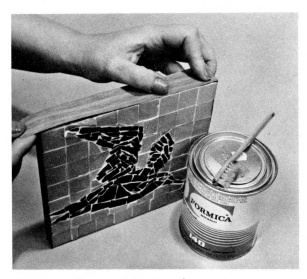

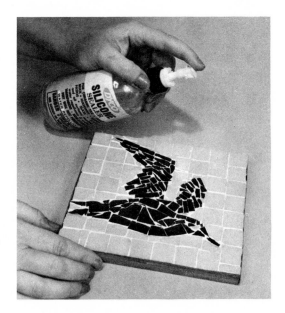

*Framing with veneer (above) and
sealing (right).*

To frame the piece with the veneer, measure each side of the piece, then add a bit extra to the cut length. Spread the bonding cement on both the binding surface and the edge of the plaque and then wait for 10 to 30 minutes for the cement to set. This cement is extremely flammable, so take all the precautions mentioned on the can. Don't smoke during this step; don't even work in a kitchen where the gas burners are lit.

Smooth the veneer down on the edge of the plaque and cut the excess away with a razor.

Seal the tile side with silicone sealer so it will be waterproof, and rub the veneer edge with linseed oil.

Small rubber disks or felt dots are then glued to the bottom of the base to keep it from slipping or scratching the furniture.

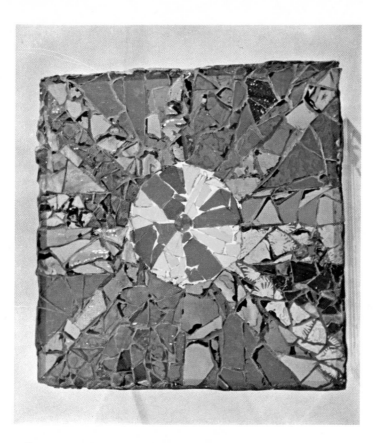

Stained Glass Mosaic

Tesserae: colored glass
Base: 3/16" glass or acrylic plastic cut to size
Adhesive: resin or white glue

grout
pigment
fine sandpaper
adhesive paper

old cotton gloves
glass cutter
spatula
pick

**MATERIALS
AND TOOLS**

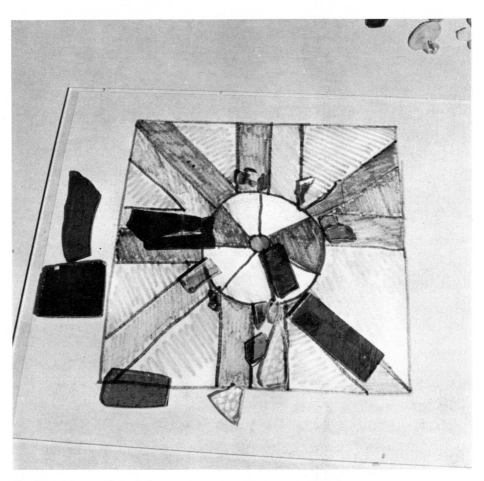

*Testing pieces against design
before gluing.*

A piece of glass mosaic is not difficult or complicated, and it can be very attractive—especially if it is placed somewhere where the light can shine through. This piece was used in one of the window panes that are stacked vertically on either side of a colonial front door.

Colored glass can be found in scrap yards or car dumps, or, in a variety of colors and textures, in a hobby shop.

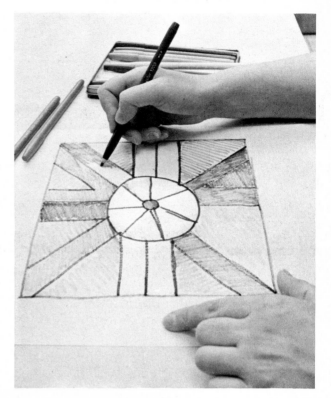

Drawing design.

When setting the pieces, be sure to wear a pair of old cotton gloves. The edges are very sharp. You may not have to cut the pieces in any way, but if you do, use a glass cutter (see Glass Cutting, page 85).

You must use an adhesive that will dry translucently; otherwise the beauty of the glass will be lost. There are special glues and resins for glass, but a white glue is fine for small pieces.

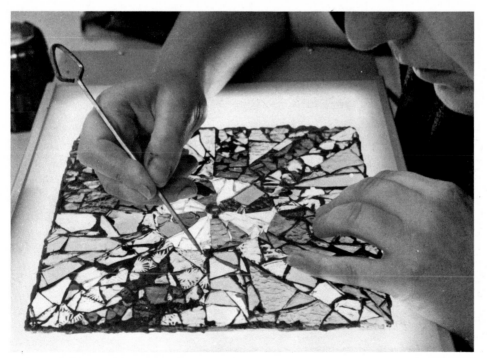

Fitting glass pieces.

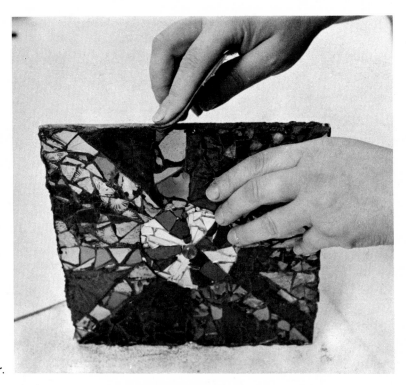

Cleaning edges with sandpaper.

Put your design under the piece of glass base and glue the glass tesserae down to fill the outlines of the designed areas.

When the glue is completely dry, mix the grout with the pigment and spread it over the piece with a spatula. Don't rub it in with your bare fingers because the glass will cut.

After about 15 minutes, clean off the excess grout. Two hours later, give it a final cleaning with a damp sponge and then polish it with a soft cloth. If there are any bits of grout on the glass, scratch them off gently with a small pick.

The excess grout at the edges can be sanded with fine sandpaper to give it a neat finish.

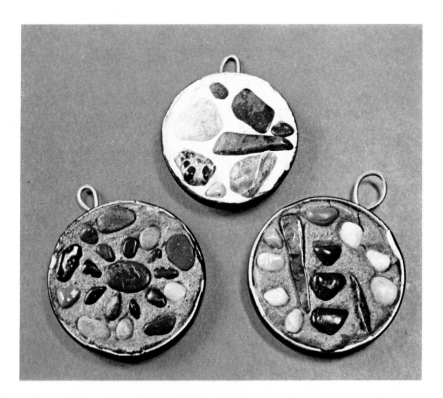

Medallions

MATERIALS AND TOOLS

Tesserae: semiprecious smoothed stones or pebbles
Base: bottle or jar lid
Adhesive: cement or grout

pigment
brass wire
spray paint
leather thong or heavy chain

mixing bowl
sponge
drill

Drill hole (below) and insert wire loop (right).

Drill a hole into the side of the lid and insert a loop of brass wire. This makes a hanging loop and reinforces the grout at the same time.

Pour the colored grout or cement into the lid until it is three-fourths full. Place the stones into it while it is still very wet, and then leave it to cure (it will take several days).

The back and edges of the lid are then painted and the piece is worn on a leather thong or heavy chain.

Place stones in wet grout.

Seed Mosaics

MATERIALS AND TOOLS

Tesserae: seeds and grains
Base: heavy cardboard or wood
Adhesive: white glue
spray lacquer

large baking pan
tweezers

A walk in the garden or along the hedge-rows or woods can yield seeds of various types, and an educated look through the kitchen or supermarket shelves provides the mosaicist with herbs and spices and hundreds of other items. There is no need to dye these products because each has its own natural dried beauty and contrasting coloring.

Seeds should be heated in a 250-300° oven for an hour. This kills any insects or insect eggs and prevents the seeds from germinating.

Your choice of materials may range among various colored lentils, peas, beans, kasha, barley, peppercorns, cloves, rosemary, oregano and other dried herbs, coriander, allspice, coffee grounds, tea, whole peppercorns, tapioca, poppy, cinnamon stick, beech, nasturtium, magnolia, acacia, and sunflower seeds.

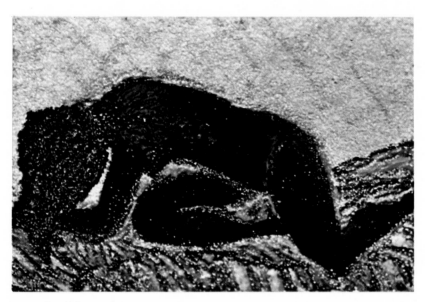

Example of dramatic use of seeds, coffee grounds and other natural materials.

It seems easier to work with these small materials if the heavy cardboard or wood is placed in a display frame, and a pair of tweezers is useful. The tweezers help to place each seed in the same direction, or contour. This gives rhythm and organization to the work. As with many other art works, plan this mosaic to contrast color, size, and texture.

Apply white glue and put the seeds in place. The glue that now fills the space with white will dry colorless and appear as an ugly, unfilled space, but a sprinkling of finely powdered spice or seed will fill this gap. When you drop this onto the wet glue, quickly tip the picture so that the excess falls away.

When the piece is completely dry, give it a spray coating of lacquer to seal the seeds and brighten the colors. A second coating a few days later will give added protection.

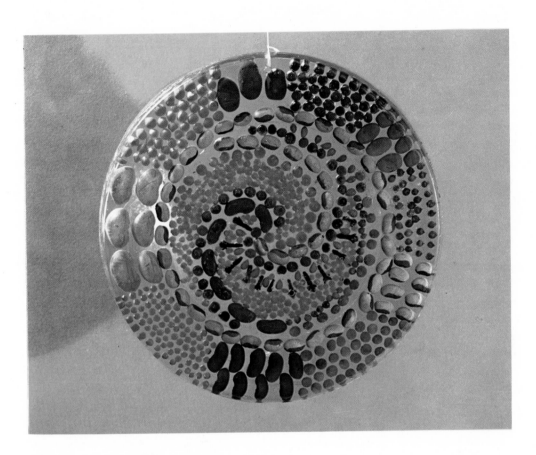

Resin Trivet or Window Hanging

MATERIALS AND TOOLS

Tesserae: seeds and spices
Base: pan or tray as mold
Adhesive: resin and catalyst
freeing agent or petroleum jelly
newspaper
baking pans

tweezers
mixing bowl
drill

This trivet or kitchen decoration is made of many different kinds of seeds and spices set in resin. First, bake the seeds in separate pans for each color in the oven at 350° for one hour, then cool.

Lay down newspapers on your work space and make sure the room is at least 70° and well ventilated. Now you are ready to get to work. Just remember to follow all the instructions given by the manufacturer on the resin can and be patient, because working with seeds and resins takes time.

"Butter" the pan you are using as a mold with petroleum jelly or coat it with a freeing agent. Then, when the piece is finished and cured, you'll be able to get it out without difficulty.

Mix the resin and catalyst and pour the mixture into the pan about 1/8" deep to give a good covering. When this is still tacky, set the seeds in a design, using tweezers. They will look better when put in position in an orderly way, and the tweezers allow you to move them to the correct angles.

Mix the resin and the catalyst in a disposable cup (not styrofoam, because this will melt), and pour the mixture into the pan so that it just covers the seeds and holds them in place. Allow it to cure.

Other layers are poured over the seeds (these may be colored with special dyes if you want a rainbow effect) until the piece is about 1" deep.

When the piece is completely dry, remove it from the mold and drill a small hole near the edge so that it can be hung on the wall when it's not being used as a trivet (for wet, not hot, platters).

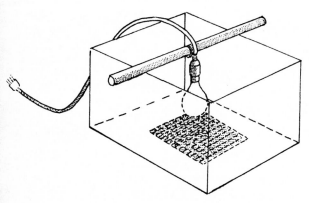

Electric light may be used to speed drying.

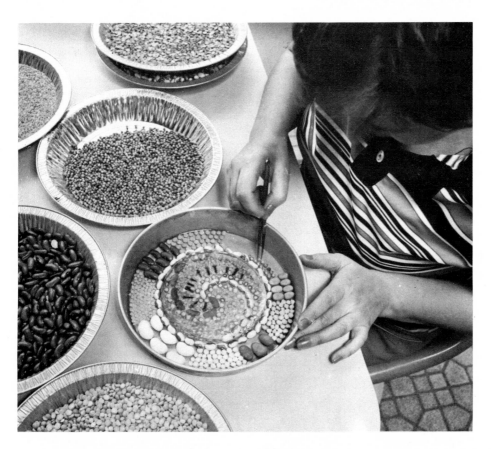

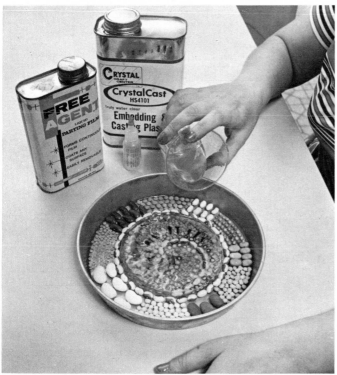

Setting seeds in tray (above);
pouring resin (left).

Drilling hanging hole.

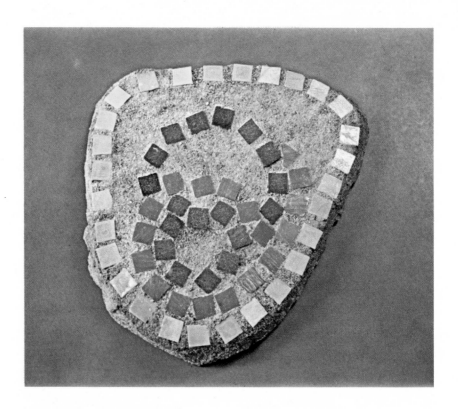

Free-form Steppingstones

MATERIALS AND TOOLS

Tesserae: pebbles, stones, smalti, or tiles
Base: mortar poured into sand form
Adhesive: mortar and acrylic liquid latex

glass bottle
plastic sheeting
box
damp sand
pieces of wire

stiff brush (toothbrush)
ruler
bottle

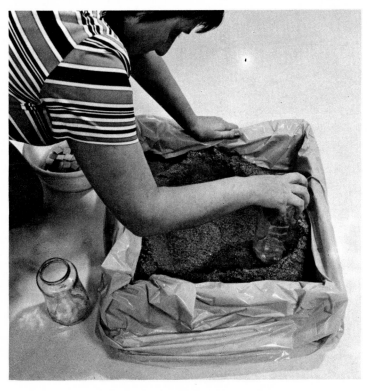

Smoothing out form with jar.

Mosaic steppingstones for your entrance or garden can add an unusual touch to the landscape.

Use a box lined with plastic sheeting or a pile of damp sand to shape your form. Make sure the smoothed impression is the same depth all around.

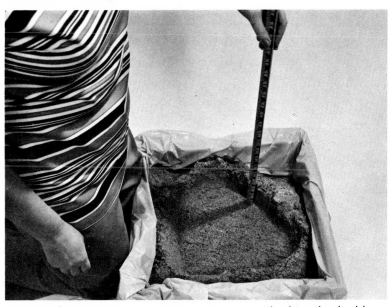

Checking depth of form.

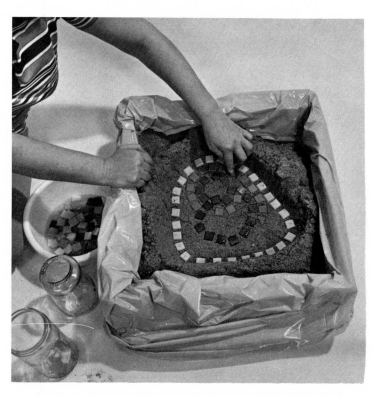

Setting tiles.

Use a straight-sided glass bottle to help you get sides even and sufficiently high.

Put the tesserae in position, right side down. Then pour a very loose blend of mortar mixed with water and acrylic liquid latex over the design about 1″ deep.

Place pieces of wire into the first layer to reinforce the mortar.

Pour more mortar in until the depth is about 2½″ and then let the piece cure thoroughly.

When the mortar is completely cured, lift the steppingstone from its sand bed and brush it clean. Wash the remaining sand off and place it in a sandy bed in the garden. (The sand around the piece will "give" and it will find its own level.)

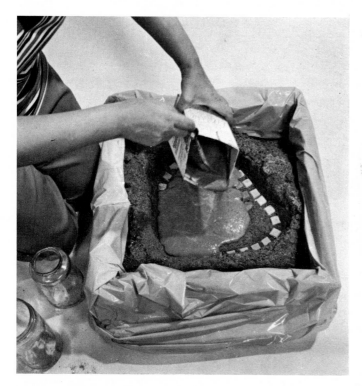

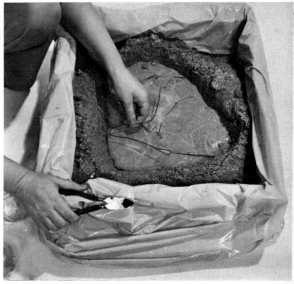

Pouring mortar (left); placing wire reinforcement (below).

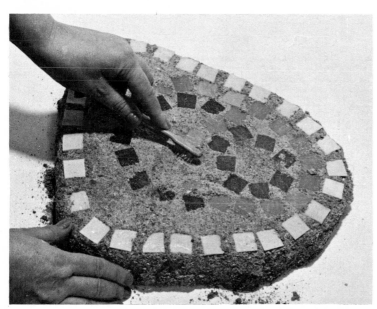

Brushing stone clean.

Eggshell Mosaics

Tesserae: broken eggshells
Base: ¾'' plywood cut to size
Adhesive: polymer cement
acrylic paint

tweezers

**MATERIALS
AND TOOLS**

Eggshells are thought to be very fragile, but actually their chemical composition makes them extremely durable. They can be used as tesserae in mosaics with quite interesting effects.

Wash and dry the eggshells and then paint the outsides with acrylic paint in as many colors as you want to use in your piece. The colors do not have to be subdued, and the mosaic doesn't have to be realistic. Both large and small shapes can be juxtaposed for effect, and colors opposed for contrast.

When the paint is dry, crush the shells with your thumb.

Mount the eggshell pieces on the base, using the direct method. Spread a small area at a time with the polymer cement.

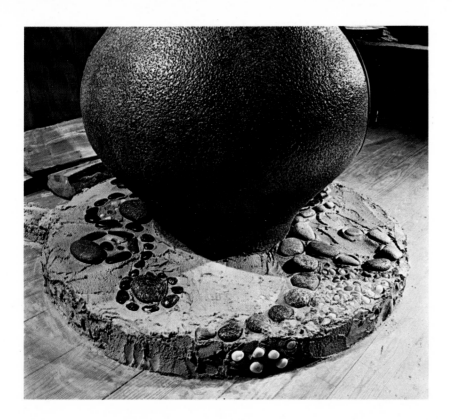

Vacation Home Hearth

Tesserae: curved bricks and small stones
Base: the floor
Adhesive: mortar and acrylic liquid latex
flooring mastic
paper
water-soluble glue
lacquer

trowel
brush

MATERIALS AND TOOLS

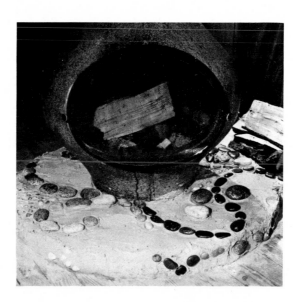

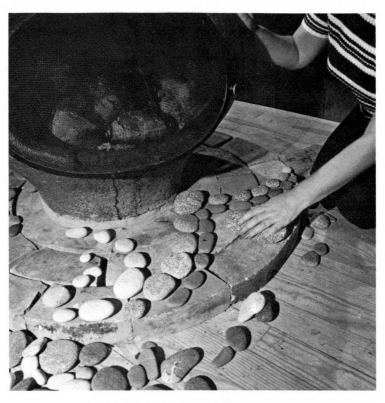

Laying out design.

These curved bricks, formerly part of a round factory chimney, became the hearth for a free-standing fireplace.

First, glue the bricks to the floor with flooring mastic and fill the spaces between the bricks with small stones. You can add two arms stretching to the wall to hold stacked logs in place if you wish.

With the larger stones, lay out a design on the bricks.

Remove the stones when you have a good design worked out, dampen the bricks with water, and trowel a thin layer of mortar over the top and sides of the bricks.

With a stick or rake, make the surface scratchy and rough. This roughness will help hold the next layer of mortar.

Mix the second batch of mortar, using one part acrylic latex and two parts water instead of plain water. The acrylic latex mixed with the mortar will hold the smooth pebbles and keep them from falling out; this is important, as they are not deeply set in the mortar.

Since the working life of the mortar and latex is only 45 minutes, spread the mixture over small portions at a time and set your stones in, using the direct method.

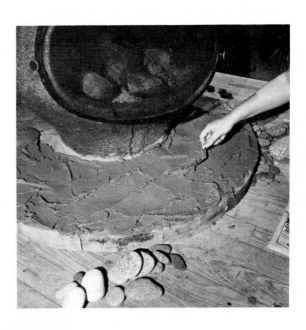

Spreading mortar (above); roughened mortar surface (left).

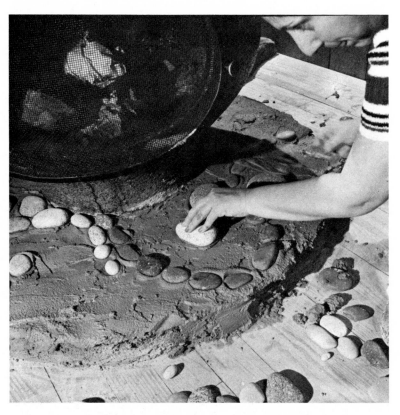

Placing stones.

Some areas are left free of stones, and these become negative areas which are part of the design. You can also fill some of these negative areas with pebbles to give them texture.

The sides of the hearth should be set in the reverse method. Glue the pebbles to a firm piece of paper with water-soluble glue and allow to dry.

After you trowel the second layer of mortar on the hearth sides, press the paper, pebble side down, into the mortar.

When the mortar has dried, moisten the paper and peel it off.

Brush the hearth clean, and give the stones a coating of lacquer to bring out their natural colors.

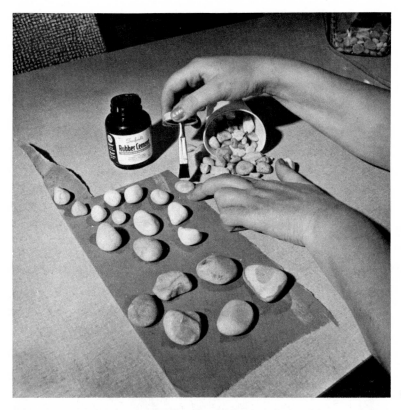

Gluing side stones.

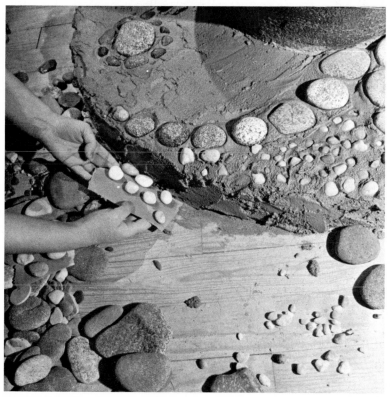

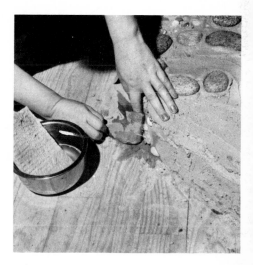

Placing side stones (left and above).

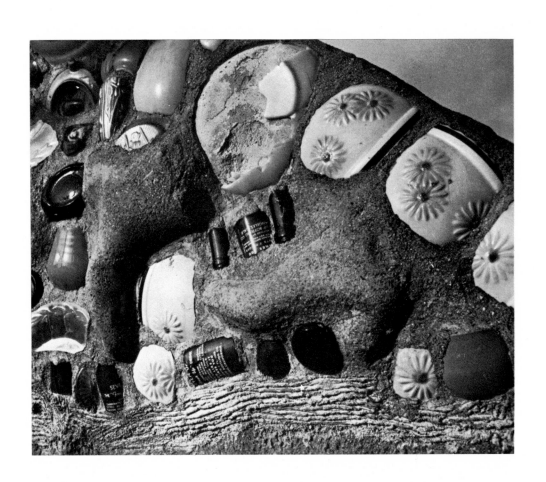

Glossary

abstract design	concerned with pure form and pattern —not representing forms of visible world
artisan	hand craftsman
bisque	unglazed pottery
to butter	to spread
capillary action	effects of surface tension of liquids
cartoon	drawing to size of finished design
casein glues	white glue from mild base, dries colorless
catacombs	underground passages originally used for burials
catalyst	substance which sets off chemical action but remains unchanged itself
ceramics	pottery art
to cure	to allow treatment to finish (to dry slowly)
direct technique	gluing of tesserae directly onto base
epoxy resin	highly inflammable adhesive—hardens on contact with air (Use in well ventilated room.)
grout	fine powdered mortar for filling between tesserae
highlight	visual brightness or accent
hardie	wedge of hard iron held in concrete or tree stump on which smalti are chipped

indirect or reverse technique	laying of tesserae face down and then grouting or pouring cement onto the back surface
mallet	large-headed hammer
media	materials as form of expression
mural	design on wall
pigment	coloring matter
tempera	dry paints mixed with an emulsifier
tessera (ae)	pieces of material for mosaics, originally marble
texture	character of surface
translucent	allows passage of diffused light, objects not clearly visible
transparent	seen through clearly
scratch surface	roughened (cement) surface onto which another layer will adhere
shards	broken pieces of pottery or glass—sometimes smoothed by the sea
smalti	original Byzantine tessera—made from glass set into bars, which are then chipped on a hardy
squeegee	implement to spread grout uniformly

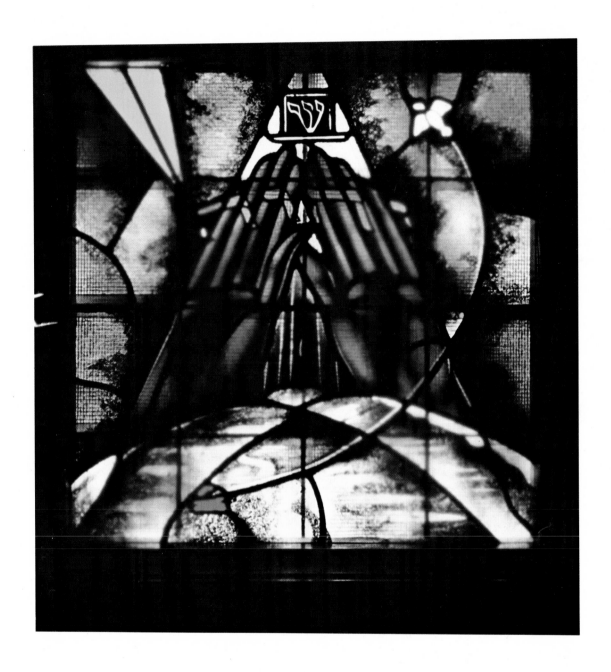

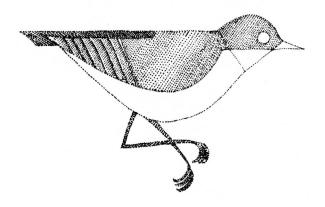

List of Suppliers

Carl Hepp Mosaic Company
3126 Nebraska
St. Louis, Missouri 63310

glass, smalti, tools, grout

Glass Masters Guild
52 Carmine Street
New York, N.Y.

scrap glass—50-60¢ a lb.
These people will be more than happy to give advice on
how to use tools and welcome visitors to see examples
of work done with glass.

Ken Kaye Krafts Company
867 Washington Street
Newtonville, Mass.

materials, tools

Magnus Craft Material
109 Lafayette Street
New York, N.Y.

limited supply of ceramic tiles
Roman tiles
miscellaneous odd-shaped tiles
grout, glue and tile cutters

The L. S. Starrett Company
Athol, Mass. 01331

tile cutters

Stewart Clay Company, Inc.
133 Mulberry Street
New York, N.Y.

glass tiles
imported Venetian glass
nippers, glues, grouts
coloring for grouts

Index

Credits

Mosaics by Beatrice Lewis; photos by Harold B. Lewis: pages 34, 40, 41, 45, 55, 56, 57, 64, 65, 67, 71, 77, 80, 84, 85, 91, 92, 98, 100, 101, 102, 104, 105, 111, 112, 113, 114, 115, 117, 118, 119, 120, 121, 123, 124, 125, 127, 128, 129, 131, 132, 133, 136, 137, 138, 139, 140, 141, 144, 145, 148, 149, 150, 151, 152, 153, 154, 156, 157, 158, 160, 161, 162, 164, 167, 169, 171, 172, 173, 175, 176, 177, 178, 179.

Mosaics by Beatrice Lewis; photos by Meryl Joseph: pages 31, 110, 126, 134, 143, 147, 163.

Mosaic by Max Spivak located in P. S. 149, New York City; photo by Meryl Joseph: page 11.

Mosaics by Anna Wyner; photos by Barnet Saidman: pages 18, 51.

Mosaics by Simon Rodia; photos by William T. Cartwright, Rededa, California: page 24, 61.

Mosaics by Jeanne Reynal; photos by William Suttle, New York: pages 26, 27 (courtesy of *Art Now*).

Mosaic by Kasimir Stachiewicz; photo by Frank Molinsky: page 54.

Photographs reproduced from the collections of the Library of Congress: pages 20, 21, 37, 88.

Photographs by Sarah Quill: pages 39, 50, 66, 86, 90, 99.

Mosaics by Unger-Schulze, designers and makers of mosaics and stained glass (London, England): pages 23, 42, 43, 79, 95, 109.

Mosaic by Antony Holloway: page 3.

Mosaic by Einar Forseth: page 15.

Mosaics by Patricia Wirtenberg: pages 54, 58, 59.

Mosaics by Meredith D'Ambrosio: pages 95, 174.

Drawings by Pam Carol: pages 32, 33, 35, 44, 72, 85, 88, 94, 102.